PAINTING SKIES
& LANDSCAPES
in watercolours

PAINTING SKIES
& LANDSCAPES
in watercolours

WILLIAM E. WHEELER

A & C BLACK • LONDON

First published in Great Britain 2005.

A&C Black Publishers Ltd
37 Soho Square, London, W1D 3QZ
www.acblack.com

Copyright © 2005 William E. Wheeler

ISBN 0 7136 6743 5

Front cover illustrations:
Top: *Dysart Harbour, Scotland*
Bottom left: *Three Cliffs Bay, Gower, West Wales*
Bottom middle: *Dusk at Low Water*
Bottom right: *Blue Mountains and Quiet Waters*
Back cover illustration: *Sails, Sea and Mountain Mist*
All cover illustrations by William E. Wheeler

Designed by Paula McCann
Copyedited by Paige Weber
Proofread by Harriet Lowe

Printed and bound in Singapore by Tien Wah Press.

A&C Black uses paper produced with elemental chlorine-free pulp, harvested from managed sustainable sources.

This book is dedicated to my friend and former student Neville Yeo
who sadly passed away before this book was published.

My appreciation to my family, friends, and many of my students,
for the help and encouragement given.

A special thank you to my daughter Angela for her help with the photography
for the book, and for her know-how with the computer.

CONTENTS

PREFACE

Throughout history, nature has played a major role in the creative process, and also as the only true primer of the arts. In the latter part of the 18th century, the poet Wordsworth acknowledged this primary role in a very short poem which contains the lines, 'come forth into the light of things. Let Nature be your teacher.' Many poets and painters of that period reflected a similar ancient respect for the visual and emotional powers of nature. To name but one, the Scottish poet James Thompson wrote 'but who can paint like Nature? Can imagination boast . . . hues like hers?' In this same context, the twentieth century must have its say. In 1923, Paul Klee, one of the world's leading artists and teachers said, 'For the artist, communication with Nature remains the most essential condition. The artist is human; himself Nature; a part of nature within a natural space.'

William is firmly located within the above tradition, a tradition within which I have seen him progress to an outstanding extent both in spirit and technique. He thrills at the idea of taking nature to task – never letting go!

In this book the format is fresh, and whether the point is in drawing perspective, colour, or materials, he opens up ideas through technical and compositional developments which, whilst illuminating, are not prescriptive. He leaves the student with firm foundations on which to build personality (even when he suggests copying and translating one of his own paintings). He remains firm on the analytical process, which he demonstrates in simple, clear and personal language. He is rightly full of the outdoors. He gives the 'land' subject only about one third of the picture space, hence his studies are packed with fresh air. This defines his primary passion for the elusive and ever-changing sky, which I'm sure lies at the central core of his personal vision. He treats the subject with both delicacy and passion, often quoting the essential, untouchable, unsolid aspects of the phenomenon via the appreciation of transparent layers of colour – 'like stroking a butterfly's wing'. One is reminded of Constable, who was 'determined to conquer all difficulties, and that most arduous one among the rest. That landscape painter who does not make his skies a very material part of his composition neglects to avail himself of one of his greatest aids.' William himself, being a watercolourist, would quote Cotman, Varley or Girtin. The sentiment is the same – direct study from nature, supported by investigation and direction from masters in the craft.

William's demonstration pieces offer sound progressive suggestions for the layering of transparent glazes of colour. Their spontaneity and technical definition is clear and enticing. He dispenses with mud! In this, probably the most difficult area, he completes his task with warmth, honesty and freedom from prescription. Techniques are well-defined in ways which acknowledge an industrious intuition, which has matured out of persistent practice, success and at times depressing failure. Watercolour is not an 'easy' medium, but alongside this fact, never forget that at times 'Nature wears a universal grin.'

An exciting challenge arises out of this book. Its style encourages response without pedantry. In writing this book, William has himself been on an artistic voyage of discovery and self-assessment. It is both personal and enjoyable. After all, 'Who can paint like Nature? Can imagination boast, amid its gay creation, hues like hers?' The challenge is yours, enjoy it.

Derek Turner MA. D.F.A. London.

INTRODUCTION

I thought it would be a nice touch to introduce myself to you, before I describe my techniques for watercolour painting. My name is William E. Wheeler and I am a professional watercolour artist living in the old market town of Pontypridd, South Wales. I am very involved in the art scene in Wales and other parts of Great Britain through running both residential and non-residential courses, day and weekend workshops, day and evening classes, and also by giving demonstrations to art societies and other groups. I have held a number of one-man exhibitions, and also had my work included in many shows in Wales and London. I have also been featured on the HTV television arts programme Primetime on two occasions. I am a regular contributor to Leisure Painter magazine, and have also written articles for Artists & Illustrators and Country Life magazines.

Many of my paintings have been purchased by private collectors in Great Britain, the United States of America, Australia, Sicily, Germany, Canada, Switzerland, Spain and Ireland.

William. E. Wheeler

THIS BOOK'S APPROACH

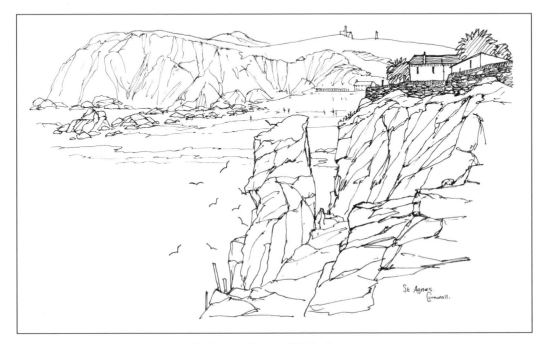

St. Agnes, Cornwall. Ink sketch.

I want the format of this book to be a little different from other art books. Although I realise that it is most important for me to give you guidance on the skill of painting in watercolour, I do not want you to look upon this as just another how-to-do-it type of book.

This book describes my way of working and the materials, equipment and colours that I use. Small drawings or diagrams are included where they might be useful to you. I include step-by-step demonstrations of selected elements within compositions to show you my methods for painting them. My intention in using this approach has been to create a book that is of greater interest to the general artist or curious reader. To this end, I also present a variety of completed paintings throughout the book, to show all the points I discuss in finished form, and with each chapter covering a particular technique, I have also decided to include a set of six cameo paintings. I hope that the reader will use both of these to analyse the sequence and colours I have used in each case and then perhaps have a go at painting them themselves.

This book should also help the inexperienced student to recognise the normally accepted methods used to produce watercolour paintings. Look upon the enclosed instructions as sound guidelines, and you will not go far wrong.

BASICS

My advice to anyone reading this book who wishes to become skilled in the use of this difficult, frustrating and magical artistic medium is to take every opportunity you can find to work outdoors. Competing with nature is one of the best ways to learn. To get the best from working outdoors, you should plan ahead. Make sure that you pack all of the materials and equipment that you will need for the trip. Also, make sure that your clothes and provisions are suitable for the weather conditions. If you can, go out painting with someone who has a little more experience at first. As you gain experience, all of this will become second nature.

My working areas

As a landscape artist who specialises in painting representational scenes in watercolour, I feel that I am blessed to have two working areas. The first is in the great outdoors, and the other is my studio at home.

When I first started painting more than thirty years ago, I was lucky enough to be one of a small group of like-minded people who wanted to learn the art of painting in watercolour under the guidance of a very talented professional watercolourist named Arthur Miles. We would spend all of our spare time painting outdoors. We painted throughout the seasons and in all types of weather conditions. Over these early years, this became an important part of my life. It is something that I have continued to do and still enjoy, and will hopefully do for the rest of my life. I sincerely believe that there is no greater teacher for the art of watercolour than nature itself.

The art of working outdoors is not as easy as it sounds, especially when you are first starting to explore the natural environment. That moment when I first sat outside with all of my painting gear around me all those years ago is a memory that remains with me to this day.

My first working area — the great outdoors.

I still remember that feeling of the unknown, and my mind full of questions such as,

'What is the best scene to paint?'

'How do I start?'

'What colours should I use?'

'How can I mix that colour?'

'Which would be the best brush to use?'

My advice to you is, do not worry too much – just paint and enjoy it! I am certain that you will improve as time goes by.

There is one more point that I must emphasise regarding working outdoors. Do not be too disappointed if you find that you are unable to complete a painting in one session outside – I seldom do. My main objective is to try to complete about three quarters of the work in the field. If I am lucky, I will add only the final touches to my work back in the studio.

My second working area is a small studio in the attic of my home, and it is an area of special importance to me. The studio is solely my space. I believe that such an area, where you are able to leave your paints, paper, uncompleted paintings, etc. out on a working surface, ready for you to work on whenever the mood and time allow you to, is very important for your development as an artist. I know from personal experience that there is nothing more distracting than having to pack up your materials and equipment after just a few hours of painting. If you are unable to create such a space for yourself, though, do not worry! You will continue to make progress wherever you work, so long as you have the desire to succeed.

My second working area — my studio at home.

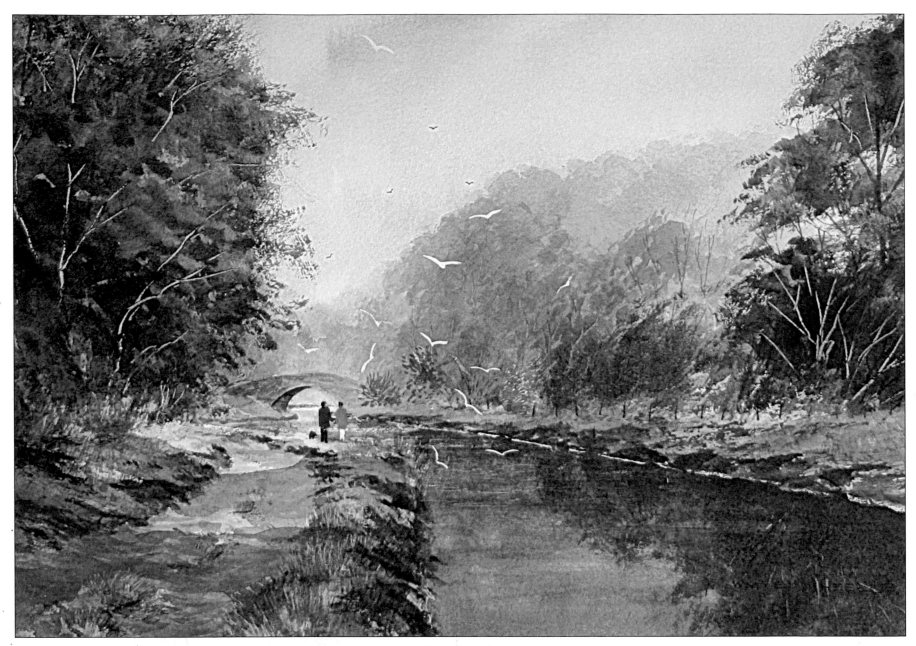

Walk on the Brecon Canal, South Wales. 28 x 38 cm (11 x 15 in.)
This canal runs between Brecon and Newport and snakes its way through some of the most picturesque countryside in this part of Wales.

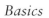

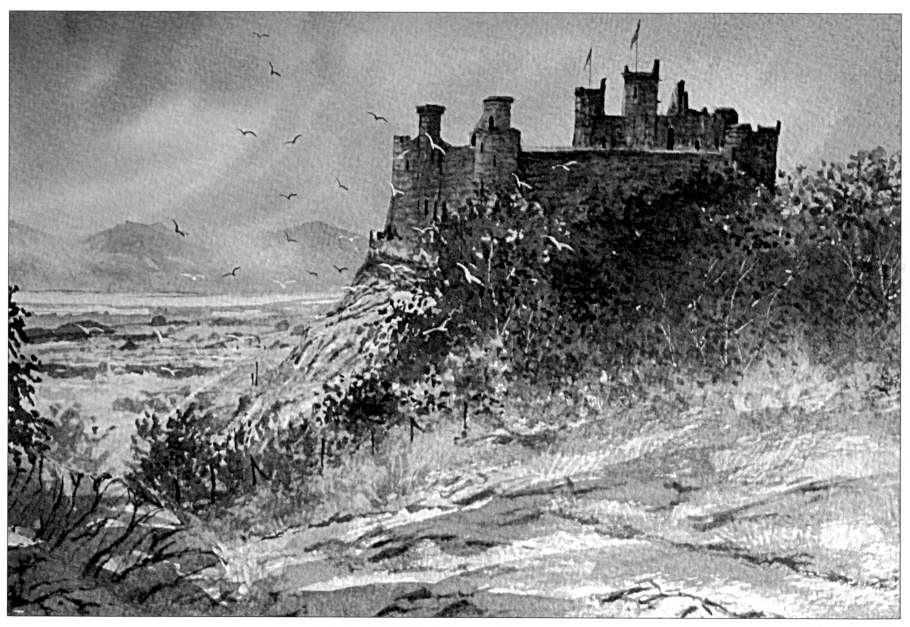

Harlech Castle, North Wales. 28 x 38 cm (11 x 15 in.)
This castle is a very important site. Perched on a rocky escarpment, it commands panoramic views across the countryside.
It is without doubt a wonderful subject to paint.

Equipment and materials

Many of us who have painted seriously for a number of years have collected a wide range of equipment and materials that we seldom use. I am no exception; I have a number of jars full of brushes that I have bought over the years, which sadly have not met my expectations. Most watercolour painters, I think, have been guilty of doing this at some time with brushes and various other items. I put it down to a lack of experience or knowledge at the time, but I am glad to say that this now only happens to me on isolated occasions.

Having learned from past experience, here is my choice of equipment:

Brushes

After more than 30 years of painting, I am still trying to limit the number of brushes that I use and I still have problems deciding which brushes to take with me whenever I am going to do a demonstration or workshop. However, I have to admit that it is getting better. The brushes shown on this page are the ones I generally use on a day-to-day basis and I believe that this selection will enable me to paint anything I am confronted with in my everyday work. They are a mixture of sable, squirrel and synthetic materials, some flat and some round. Those shown are made by the following companies: Stratford York, ABS Brushes and Da Vinci.

Selecting a brush is a very personal thing. Many questions go through your mind, such as, 'Should it be round or flat?' and 'What size do I need?' To prevent you from making the mistakes that I did, let me suggest that you try a brush before you buy it. If you are a member of a painting group or society and you see someone using a brush that looks interesting, why not ask if you can try it? This way at least you will know if the brush feels right in your hand. I like to use sable and squirrel brushes, but that is my personal choice. There are many other types of good quality brushes on the

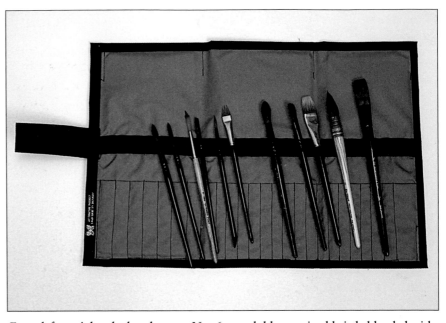

From left to right, the brushes are: No. 6 round, blue squirrel bristle blended with synthetic fibre; No. 4 round, blue squirrel bristle blended with synthetic fibre; No. 3 rigger, extended synthetic fibre; 1/4 in. flat, blue squirrel bristle with blended synthetic fibre; 1/2 in. comb, sable bristle; No. 8 round, blue squirrel bristle blended with synthetic fibre; 3/4 in. flat, goat bristle; No. 10 squirrel mop; 1 in. blue squirrel bristle blended with synthetic fibre.

market, so choose yours carefully within the range you can afford.

It is no use buying good quality brushes unless you have a good brush case in which to keep and protect them. The one I use constantly was made by one of my students, and really was made to order. It is made of a waterproof material with inserts of a very lightweight plastic that keep the case rigid. The brushes fit into slots which vary slightly in size to accommodate those with differing thicknesses of handle. It has an elasticised band which prevents the brushes from falling out, which is a useful thing to have when working outdoors. It folds over and is secured with a Velcro strip.

Pencils

Very often pencils are regarded as the poor relations when we think of materials and equipment, but they are so very important to the landscape artist. You should always choose a good quality make of pencil. I use a 2B Derwent Graphite pencil for all of my preliminary drawing before painting starts. This grade is soft enough not to damage the surface of the paper, and hard enough not to spread under your hand.

> **My own personal choice for brand of pencils is Derwent Pencils produced by the Cumberland Pencil Co Ltd, and I will be using a 2B pencil from their Graphite range throughout this book.**

Paper

There are now so many watercolour papers available that it would be very easy to get confused. I have to say that most papers are of a high quality. Over the years, I have tried many of them.

> **For the purpose of this book I have decided to use Bockingford 250 lb (535 g/m) NOT and Saunders Waterford 300 lb (638 g/m) ROUGH from the St Cuthbert Mill. I use both of these papers for my day-to-day painting, and enjoy the act of painting on them very much.**

The following information is for those of you reading this book who are just starting out on this artistic adventure and who are finding the basics of watercolour papers a little confusing. Many of you who have painted for a while may know quite a lot about these papers, but here are the basics.

As watercolourists we will come across three main types of paper:

Hot Pressed (HP), which has a smooth surface with little or no texture, and is seldom used by watercolourists;

Not Pressed (NOT) (CP), a paper with a fine surface texture and one of the most popular papers; and

ROUGH, a paper with a rougher texture, which can vary with different makes of paper and which is used by artists to get more texture and atmosphere within their paintings.

> **The weight of paper is based on a ream of paper (500 sheets). The thickness of the paper determines the weight, e.g. 500 sheets = 140 lb (300 g/m). The heavier the poundage, the thicker the paper.**

Stretching paper

As a guide, 140 lb (300 g/m) and thicker paper can be used without stretching. Many artists recommend stretching the heavier papers, but I never do. Any paper below 140 lb should be stretched, however.

Let me explain the technique. You will need:
- A panel of board that is a little larger than the paper that is to be stretched
- Water-soluble gummed tape, approximately two inches wide
- A sharp blade
- A sponge or cloth

Then follow the step-by-step demonstration on the next page.

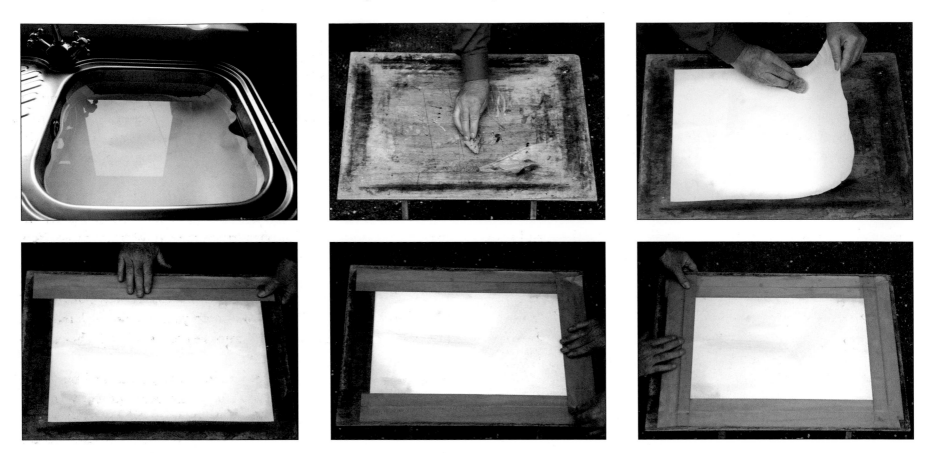

Step 1. *Place the paper in a bowl of clean, cold water and leave it to soak until it is quite pliable. (The amount of time needed will vary for different thicknesses of paper.)*

Step 2. *Cut four strips of tape that are just slightly longer than the edges of the paper.*

Step 3. *Dampen the surface of the board with the sponge.*

Step 4. *Lift the paper out of the water by the corners and shake off the excess water*

Step 5. *Place one edge of the paper onto the board, leaving room for the tape, and gently press it into position using the sponge until all air bubbles are expelled and the paper is completely flat.*

Step 6. *Dampen the gum side of tape and lay it strip along the edge of the paper, making sure that half of the tape is on the paper and the other half is on the board. Repeat this for the other three edges.*

Step 7. *Run your nail gently along the edge of the paper to ensure that there are no air bubbles. Lay the board flat and allow the paper to dry until its surface is taut.*

Paints

There are many different makes of watercolour paints that you can buy. All are of good quality, yet all are a little different. We will look in detail at the two grades of watercolour paint that are usually readily available and are the most popular among water-colourists: artist quality colours and student quality colours.

Artist quality colours: these are the most expensive but the best quality watercolour paints. Made using the finest gums and pigments, the paint has strength and brilliance of colour, and good colour stability, allowing the artist to produce works of incredible purity and luminosity.

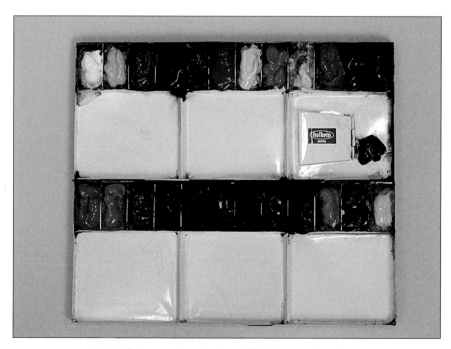

My Holbein metal paint box, filled from tube colours.

Student quality colours: this range of colours is more economical for the would-be artist because many of the more costly pigments have been replaced with a less expensive alternative. Although cheaper in price, they still allow the production of high quality paintings. I used student quality colours for many years, gradually adding artist quality colours to my palette, finding that these enabled me to mix stronger colours using less paint. However, at the end of the day, you buy what you can afford.

Watercolours can be purchased in tubes, ¹/₂ in. pans (small plastic pans filled with paint), full pans (twice the size of ¹/₂ in. pans). You will see from my paint box that I favour tube colours – I just replenish the colour in my paint box from a tube as required. Most of the boxes on sale (plastic or metal) are usually sold containing ¹/₂ in. pans or full pans filled with pre-selected colours or you can do as I did and purchase an empty box and fill it with the colours of your choice.

My advice to those of you who are about to go out and purchase paints for the first time is to stop for a moment and consider the following questions: What subjects would you like to paint? Are you going to paint large or small? Will your subject be landscapes, marinescapes, etc.? Do you intend to paint miniatures?

Each of the above questions, if thought out carefully, will help you to decide on whether to buy your paints in tubes or in ¹/₂ in. or full pans. If you intend to paint large landscapes, for example, it would not be very practical to purchase a small ¹/₂ in. pan box. It would be better to go for tubes or full pans so that you would be able to take up a lot of colour with ease. If, however, you intend to paint smaller paintings or miniatures, then a ¹/₂ in. pan box would be ideal. Think carefully and buy wisely!

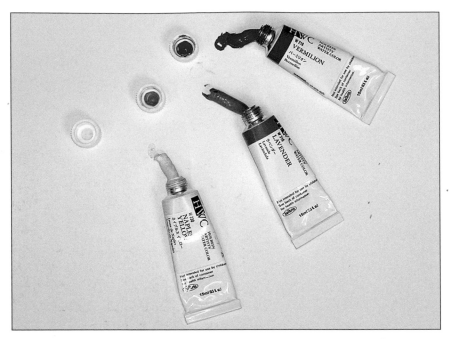

Holbein Artists' watercolours in tubes

As you become more experienced, I am sure that you will need to adjust this list over and over. This is good, because it means that you are continuing to learn and becoming more selective.

Example of a ½ in. pan paint box.

Additional materials

There are a few additional items that you will also need. These are:

- A backing board to support your paper
- Masking tape
- A 2B pencil
- A water pot
- Tissues
- Putty rubber.

If you are working outdoors, you will also need the following:

- A bottle for carrying water
- A folding seat
- A warm waterproof coat and of course a bag for carrying all of your equipment
- An easel is useful, but not always essential.

Example of a full size pan paint box.

Choice of colours

A large percentage of you who are reading this book have probably already decided on your palette of colours. If this is the case, then you could choose to skip forward over this section. For those of you who have just started to paint, however, I will list here my favourite colours for your guidance, together with their transparent or opaque properties. Remember that these colours were chosen for this list simply because I enjoy using them.

T = Transparent
O = Opaque
S / T = Semi-transparent

Burnt Sienna (T)

Light Red (T)

Cadmium Red Light (O)

Rose Violet (T)

Prussian Blue (T)

Cerulean Blue (S / T)

Naples Yellow (O)

Permanent Yellow Deep (T)

Cobalt Blue (T)

Ultramarine Blue (T)

Aureolin Yellow (T)

Permanent Yellow Light (O)

Payne's Grey (T)

Neutral Tint (T)

Raw Sienna (T)

Lemon Yellow (T)

Verditer Blue (O)

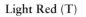

Lavender (O)

The paintings shown throughout this book have been painted using Holbein Artists' Watercolours, and you will notice that most of the colours I have selected to use are transparent. I have to say that these paints have been a joy to use.

As you will see on the previous page, my purple-red colour is rose violet, which to the artist's eye is in the crimson range of colour. From this point onward I will refer to this colour as crimson for the sake of continuity throughout this book.

Perhaps you will have noticed that my palette does not contain any ready-made greens. The reason is that I enjoy mixing my own green and grey colours. The mixing of greens is probably the biggest stumbling block that the landscape artist faces. To help you, I have decided to include a simple exercise to give you an idea of the range of greens that can be mixed from the colours in your palette.

First attach a sheet of watercolour paper to a board, and then select two yellows and two blues from the colours in your palette and apply them to the paper. (I used paint straight from the tube. If you haven't got any tube colour, use a thick mix of colour from your palette.)

Gently move some of the pigment around with a brush to start to form greens. Using an atomiser, wet parts of the pigment and then slope your paper to allow the pigment to run and intermingle to form a range of greens.

If you repeat this exercise using different combinations of all the yellows and blues in your palette, you will soon begin to realise how many greens you are able to mix from so few yellow and blues. By the time you have completed all these exercises, your knowledge of greens will have increased dramatically. You can of course use this exercise with various colour combinations.

The step-by-step demonstrations and finished paintings through-out this book also contain a great deal of information about the way I mix greens. There is no shortcut to success, so study and practice really are the best ways to learn the art of mixing greens. I am sure that with a little practice you will turn out some lovely work. The important thing is to enjoy the act of painting.

Glazes

What is a glaze?

The easiest way of describing a glaze is to say that it is a thin wash of transparent watercolour applied to a watercolour paper. The technique of actually painting with watercolour glazes is a little more complex than this, however.

I have always held the work of the Victorian watercolourists in very high esteem, and I believe that we need to look no further than the period of 1750 to 1880 in the UK to see works of a very high standard, many of which were produced using glazes. Some notable examples are the works produced by J.W.M. Turner, John Sell Cotman, John Varley and Thomas Girtin, to name just a few. When I try to make a comparison in my mind between the quality and sophistication of the paints and equipment that we are able to buy and use today and those used by these Victorian artists, I am totally amazed that even after all these years there is still a freshness and sparkle in many Victorian paintings that is often lacking in many present-day works.

I believe that the main reason for this was that these artists recognised just how important the technique of using glazes was in the production of a good painting. This being so, the technique was developed to a very high standard.

I hope that my interest in glazes, together with my use of them in this book, will help to revive the use of this technique a little and will at the same time help to create an excitement within the reader and a desire to put brush to paper. As a tutor of watercolour I am frequently asked the questions, 'Is glazing useful as a technique?' and 'Will it improve my work?' My answers to both of these questions is without a doubt, yes!

The technique is covered in greater depth in the next section, and in the paintings shown throughout the book.

An exercise in glazing.

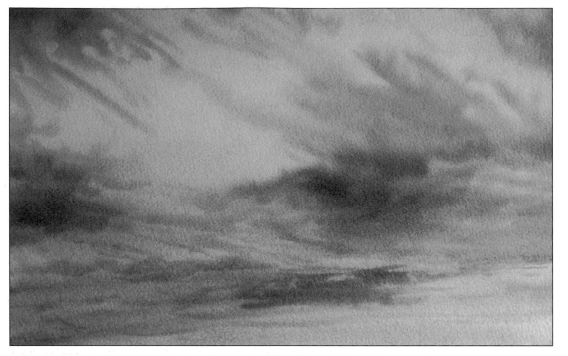

A glazed skyscape. 28 x 38 cm (11 x 15 in.)

Say goodbye to mud forever

For those of you who are just starting out on this magical, artistic adventure of learning how to paint in watercolour, this title must be more than a little confusing. Let me hasten to explain! The term mud in watercolour parlance refers to the drab, opaque grey or brown colour which is formed by overbrushing or overmixing. This unhappy state of affairs usually occurs through a lack of knowledge or experience. Before we can progress from this point, I think it is useful to go back to the basics for a few moments.

Watercolour technique

In its most simplistic form, the art of painting in watercolour consists of applying thin transparent washes of colour to a special paper surface. As we seldom use white paint, we have to look upon our white paper as our whiteness or brightness. So it follows that the fewer thin, transparent washes of colour you apply, the brighter or cleaner your painting will look. If, however, the paint is applied too thickly, or too many colours are mixed together, be it on the paper or in the palette, you will obliterate the whiteness and reflective properties of the paper. This overbrushing or overmixing usually produces a drab, opaque grey or brown colour usually referred to as mud. This in turn leads to a dull and uninteresting painting that lacks brightness. We all produce this type of painting at some stage during our quest to master the art of painting in watercolour.

I am going to present you with two very important rules. If you take these on board, they will certainly help you to banish mud from your paintings forever. The rules are:

- Apply your paint with a touch so light that it is like stroking a butterfly's wing. You should hardly apply any pressure on the paper. Do not mix your paint on your paper using a vigorous action. Use the least number of brush strokes you can manage to apply the paint.
- Let each layer of thin transparent colour dry thoroughly before applying the next.

It really is as simple as that! If you take my advice and follow these two simple rules, you will say goodbye to mud on your paintings forever. Experiment, and be delighted with the results.

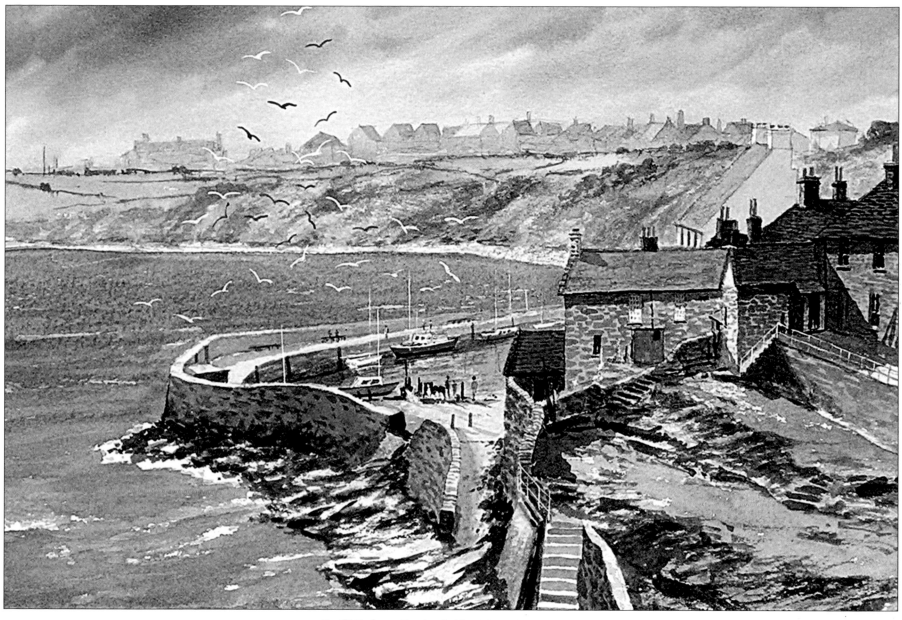

Crail Harbour, Scotland. 28 x 38 cm (11 x 15 in.)

This lovely harbour setting is one of nature's natural compositions. It required no design adjustments; it was perfect – I just sat down and painted it.
I thoroughly enjoyed the whole experience and am quite pleased with the finished painting.

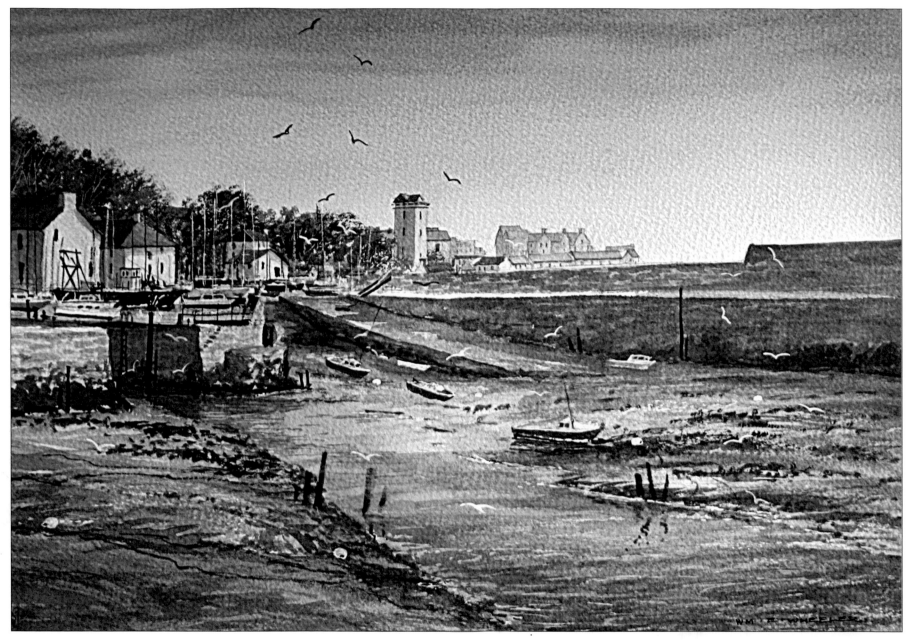

Dysart Harbour, Scotland. 28 x 38 cm (11 x 15 in.)

This attractive old harbour, which dates back to the 17th century, has a feeling of old world charm and is a good example of a natural composition.

COMPOSITION DESIGN

Foregrounds

Painting in watercolour is, I believe, the most difficult of all artistic skills to master. The medium is so demanding that it is easy to become demoralised at an early stage. There are a number of stumbling blocks that are sure to be encountered along the road to success, and painting foregrounds could easily be one of them.

Let's look a little closer to find out why the painting of foregrounds creates so much fear and apprehension. I think the main reason is that we know that anything in the foreground will be closer to us, and therefore should be seen in greater detail. It might therefore seem more difficult to paint. This is not necessarily so. Throughout this book you might have noticed that I use the word 'simplification' quite a lot. This is because I look upon the act of producing a painting as a simplification of a composition taken from nature, and not a copy. I always try to think of each area of a painting in a simplistic way, and foregrounds are no exception. Students often ask me, 'What is the best way to paint foregrounds?' There is no blanket answer to this question, however,

> Here is a little tip that is worth trying. As you look at the scene you have decided to paint, half-close your eyes, and you will see your composition plus the foreground with very little detail. In this way it will appear simplified!

because each foreground that we paint has different requirements. The overall approach remains the same, however – simplification!

Below I have shown a few small studies with different foregrounds to help you. You might also want to study the foregrounds in all of the paintings shown throughout this book. I am sure that once you have put some of my ideas into practice, the painting of foregrounds will hold no fear for you. I hope that the following examples will help you to approach the task of painting foregrounds with a new-found confidence. Just look, simplify and practise.

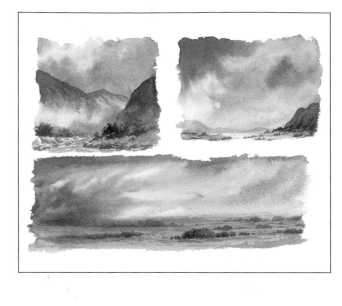

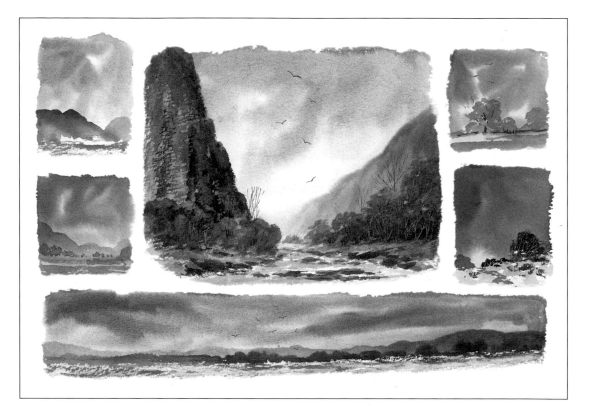

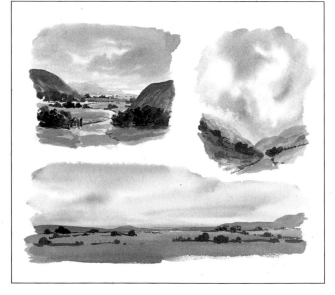

Here is a selection of my cameo paintings to illustrate my technique of painting fore-grounds. My cameos are not finished paintings; they are only sketches, done without any drawing. They are simply painted straight on to the paper from the mind. I don't worry if the lines are not straight, etc. Try painting cameos yourself – it really is a wonderful way to free up your painting technique. Simply place a sheet of watercolour paper on your board and decide how many cameos you want to paint. Then, without thinking too long or hard, paint in the sky for each cameo. Before these have completely dried, paint in simple landscapes to complement each sky study.

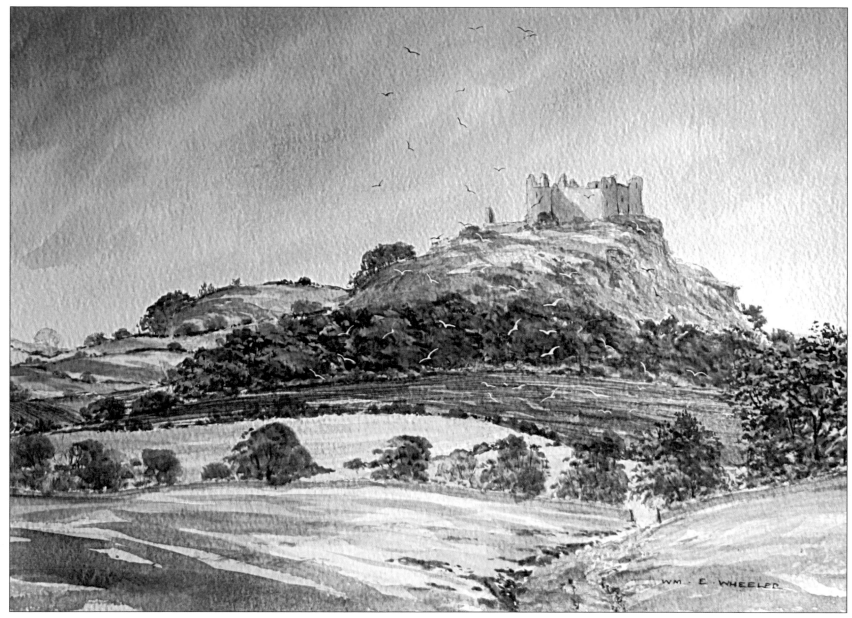

Castell Carreg Cennen, West Wales. 28 x 38 cm (11 x 15 in.)

This must be one of the most impressive edifices of its kind in Great Britain. It can be found perched on a rocky outcrop 360 feet above the Tywi valley, near the old market town of Llandeilo in West Wales. I have included this image here just to show how simply I painted in the rough pasture land in the foreground.

Compositional design

All artists are at some time during their painting lives confronted with problems resulting from compositional errors. What is composition? I like to describe it as a technique that helps us as artists to produce a painting that has balance and harmony, and that creates the effect of distance and size. In a simplistic way, it could be described as the act of putting together a scene that is acceptable to our eyes. I like to refer to the above act as compositional design, because in reality as landscape artists we usually have to alter a composition that we want to paint in order to make it acceptable to our requirements. We are in fact redesigning a piece of nature!

The rules that will enable us to use compositional design, and thus improve our drawings and paintings, are few, and they are very easy to understand and use.

The object of good composition is to encourage the viewer to enter your painting and to experience a unique visual adventure. So it is very important that you should try to incorporate these rules into your work each time you paint, to ensure that you will succeed in attracting the viewer.

I have attempted to make it a little easier for you to understand and use these simple rules each time you paint. Important points are shown in tinted boxes and followed by two small diagrams: one diagram shows the incorrect way to compose a design, and the other shows the correct way. I am sure that if you spend a little time practising using these rules, you will notice an improvement in the visual quality of your paintings.

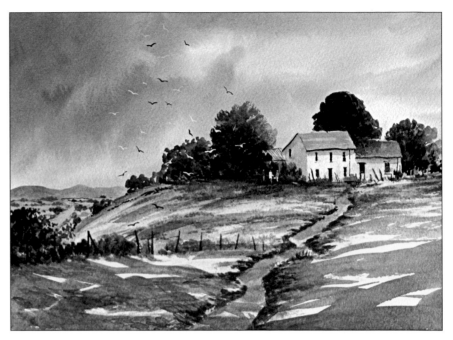

Ty Rhiw (Hill House). 28 x 38cm (11 x 15 in.)

As an artist who has spent over 30 years drawing and painting outdoors, I am often amazed at the simple compositional errors I see whenever I visit exhibitions – very often by experienced artists who should know better. The following are the basic rules of composition.

(A) Never place your point of interest in the centre of your painting. Place it off-centre and provide a lead-in to the point of interest. The viewer will then be able to enjoy an artistic adventure.

(A) **Wrong**

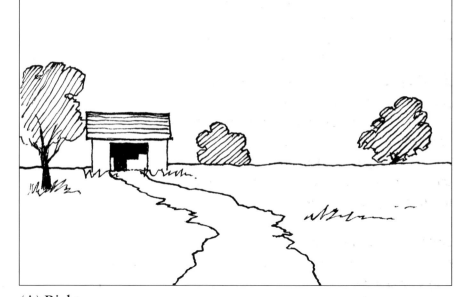

(A) **Right**

(B) Try not to place an unbroken line or band – such as a fence, hedge or wall – across the front of your painting.

If it is necessary to have one of these lines running across the foreground of your painting, make sure that you leave access gaps in it, in order to allow the eye to travel through into the landscape beyond. If you have a gate in the wall, fence or hedge, make sure that you leave it open. This may sound a little stupid, but the eye will see this gate as an obstruction and will have difficulty in passing through it to the point of interest. Leave the gate open and the eye will travel past it without any problem.

(B) **Wrong**

(B) **Right**

(C) **Never place two objects of similar size and tone closely opposite each other. Once again the eye will have difficulty in continuing its journey past them. Simply vary the size and tone of one of them.**

Compositional errors are, I think, simply optical illusions and there are many of them just lying in wait to catch the unsuspecting artist out. This particular illusion can arise whether you are painting buildings, landscapes or people.

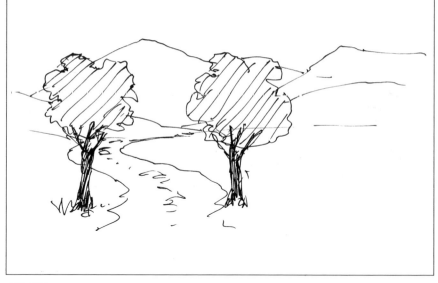

(C) Wrong

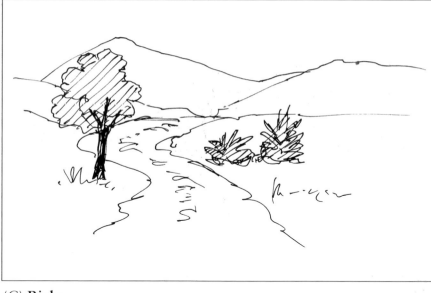

(C) **Right**

(D) Never allow diagonal lines such as roads or rivers to run to or from the corners of your painting. This will lead the viewer away from the point of interest and out of your painting. Our aim as artists should be to encourage people to study our work for as long as possible – good composition can make this happen.

When I was in art college studying the concepts of design, I was always told that, 'If it looks wrong, it is wrong' – or at least one element within the scene is wrong. The difficulty is in working out what the problem is and solving it in a practical way.

(D) **Wrong**

(D) **Right**

Besides the basic rules listed above, we must also try to achieve good visual balance in all our compositions. Visual imbalance is something we encounter every day of our lives. As artists it is very important that we learn to recognise it and are able to adjust the elements that cause it to occur. In our everyday living it could be as simple as a picture in our home not hanging straight or too many paintings hung on one side of a room and two few on the other side, creating a lop-sided effect. As watercolour artists we are most likely to see it in our proposed compositions and paintings. Is there such a thing as the perfect composition? In my experience there is not – we usually have to adjust or simplify the scene. For example, we might consider leaving a tree out or moving a house back a little. What we are actually doing is obeying the rules of composition and at the same time improving the visual balance of the scene before we start to paint. I have provided a few simple examples to show you what I mean.

Wrong. *This simple composition is very unbalanced, having too much weight on the left-hand side of the drawing.*

Right. *This example is much more balanced, providing the viewer with a more acceptable composition.*

In a balanced composition you cannot have two centres of interest. Some years ago, I was asked to judge a local art exhibition. One of the paintings in the show by a well-known local artist was of a very high standard with the exception of a very basic compositional error. The artist had painted a river and a road running along side each other going into the painting and then suddenly, for no reason, the river went off to the left and the road to the right, thus creating two points of interest. This proved to be most confusing for the viewer who had no idea which one to follow. For me the painting was ruined. Look at the sketches below and on page 35, which show a similar type of composition and I think explain the problem more clearly. Although they differ, they both unsettle the eye. Your eye, once trained, will always let you know when something in your painting is not quite right. Remember: if it looks wrong, it is wrong!

Wrong. *This scene breaks two of the main rules of composition. The main tree shape has been placed in the centre of the scene, and there are two paths, each one taking the eye out of the composition.*

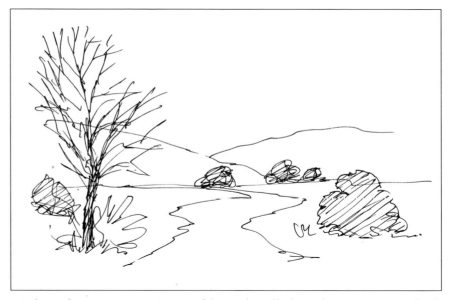

Right. *This is a more acceptable and well thought-out scene which uses the rules to good effect.*

I realise that I may have made the rules of composition sound very easy but they really are that simple. The difficulties arise when you try to use them as you look and draw out a composition. It is an aquired skill and one that you can achieve. I can only advise you to practise using the guidelines for every composition that you draw over the next few months and you will improve the visual quality of your paintings beyond all recognition. After a while compositional design will become second nature.

> **The sketches below sum up two of the main principles you need to remember to produce a successful composition: avoid diagonal lines running to or from the corners of your painting and try to achieve good visual balance.**

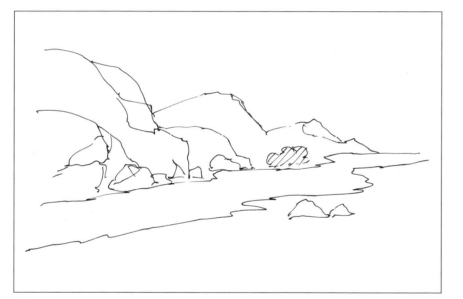

Wrong. *This scene is quite unbalanced because there is too much tonal weight on the left-hand side of the composition. Also, the path leads the viewer out of the painting.*

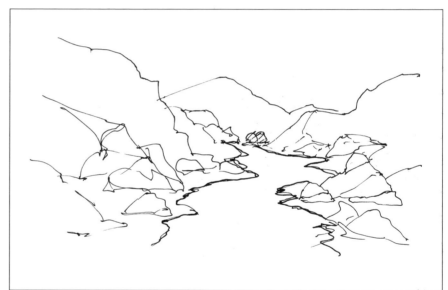

Right. *This composition is more equally balanced, with a path snaking its way to the centre of interest – a very acceptable layout.*

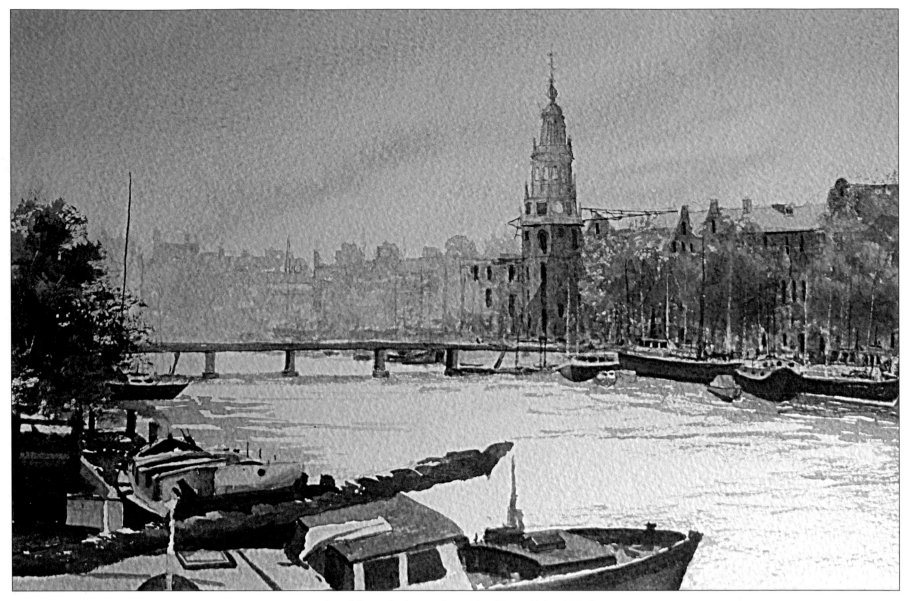

Canal Scene in Amsterdam. 28 x 38 cm (11 x 15 in.)

I came across this wonderful canal vista in Amsterdam whilst running a painting course in Holland. We had decided to go into the city to do some sketching and this was one of the many subjects that attracted our attention. Amsterdam is a very beautiful location for artists and, like most major cities, provides such a variety of interesting subjects just waiting to be painted – I cannot wait to go back there.

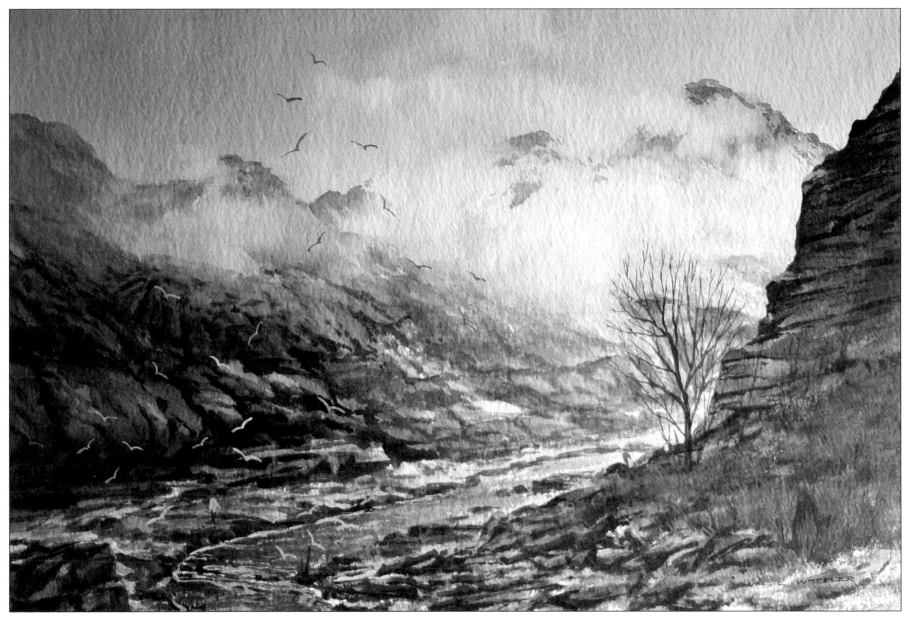

In the Bed of the Valley. 28 x 38 cm (11 x 15 in.)

I have to say that many things interested me about this scene: the way the clouds and mist hung over the top of the mountain creating a mysterious atmosphere, the variety of different shapes in the rock structures and the way the river snaked its way along the valley floor.

TECHNIQUES

Painting skies

My introduction to the technical difficulties encountered when painting skies began in the early 1970s, when I left art college and started painting outdoors with a small group of like-minded people under the guidance of a professional artist. It was during these early years that I began to realise my natural ability for painting skies. The very act of working outdoors is the best way to learn how to paint, and over the years while working outdoors I have developed my own personal method of depicting skyscapes, as I sometimes like to call them.

My own technique of painting skies depends entirely on the use of glazes (see page 25), but you will notice that this technique is different from that of many other artists because much of the whole procedure of painting the sky is carried out in a single operation. To help make you familiar with my technique, and to show you how exciting this area of painting can be, I have included a number of examples that show a variety of different sky types. I also wish to show you how essential it is for landscape artists to master the art of painting skies. They set the scene, so to speak, by adding light, atmosphere and character to the chosen subject.

It is not essential to learn the various cloud types to become a good sky painter, but it is sometimes useful to have some knowledge of them. That said, I am not going to give technical descriptions of every type of sky or cloud here. All of the illustrations of skies shown in this section have been included simply because I enjoyed looking at them and painting them. Instead of giving step-by-step details for how to paint each particular sky, I intend to

It is very important as an artist to observe and paint a sky whenever the opportunity allows you to do so. I try to paint at least one sky every day. Most times I succeed in doing so, and I find that this discipline prevents me from getting stale or becoming complacent.

describe my way of painting a sky in general. All of my skies are painted using the same technique. The only things that differ from painting to painting are the colours and designs. The technique, though, is the most important element needed to paint successful skies. Combine technique with observation and you will soon be painting skies with confidence.

For some of the examples shown below, I will describe the colours used. For others, I will let you work them out for yourself. Try copying some of these paintings, and you will learn a great deal about painting skies.

Before you start, take a little time to study and practise the technique shown below. In this way you will be able to enjoy and capture the magical qualities of this most illusive part of the landscape.

Painting skies using my technique

All of my skies, whether they are painted outdoors or in the studio, are painted in the following way:

- I like to use 140 lb up to 300 lb paper. If the paper is over 140 lb, I usually decide not to stretch it. I simply fix it to the board using a little piece of white tack at each corner, on the back of the paper. I have found this method to be very successful. It also allows me to use every piece of my paper.
- Sometimes I draw in the outline of my landscape lightly before painting, using a 2B pencil. At other times, I may not draw anything. It really depends on the composition and subject.
- Using a large sable brush (a No. 14 or No. 16 round brush, or a 1 in. flat brush), I apply clean water to my sky area (usually about two thirds of the paper). While this is very wet, I paint in the colours of the sky and then leave the paper to dry.
- All of my skies are painted in one operation.

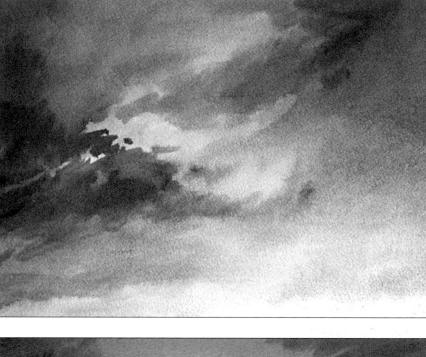

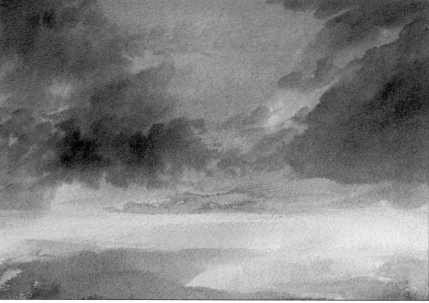

Remember that while the sky area remains wet, you can safely continue to apply colour. However, once the surface starts to dry, you must not touch the paper with your brush. The whole surface must to left to dry. If you do touch the paper once it has started to dry, you will ruin your sky with unsightly dry marks. However, when the lower area of the sky is almost dry, it is sometimes possible to paint in distant mountains, trees, etc. in a soft, hazy, atmospheric way.

I never deviate from my technique of painting skies. You must of course observe a variety of skies, and attempt to paint them directly from nature as often as possible. It is only with constant practice that you will gain a degree of mastery in this particular skill.

The paintings I have selected to reproduce here show a variation of sky structures. It is this ever-changing background of designs that has made the study of skies such a fascinating subject for artists over the centuries. Before looking at the sky studies, I would like to mention a few of the colours that I use. These are for me essential for the painting of realistic skyscapes.

You will see that I like to use Naples yellow a great deal. It is indeed one of my favourite sky colours and it is an opaque colour, but as I have already stated, opaque colours when thinned out produce some very lovely glazes. My personal view is that there are only three yellows that help to produce natural-looking skies. Along with Naples yellow, these are raw sienna and yellow ochre. Remember that because Naples yellow and yellow ochre are opaque, you will need to dilute them more than transparent colours.

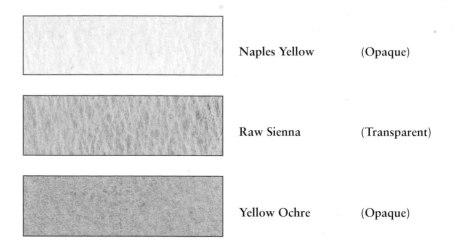

Naples Yellow (Opaque)

Raw Sienna (Transparent)

Yellow Ochre (Opaque)

Most other yellows will tend to turn green when they come in contact with blues. At the end of the day, however, the yellows that you choose will depend on your personal preference. In the same way, most blues could be used in the painting of skies, but I usually use the following:

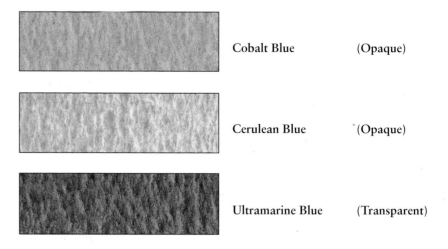

Cobalt Blue (Opaque)

Cerulean Blue (Opaque)

Ultramarine Blue (Transparent)

The above blues are my standard colours, although you can, of course, use any blue that suits your requirements.

To introduce you to my way of painting skies, what follows is a step-by-step demonstration of one of my paintings. Because my method of painting skies is free and spontaneous, this demonstration will be painted without any pre-planned drawing.

Step 1. *First I wet the whole of the paper using clean water. Using the following colours, I designed my sky. Orange was applied to the middle area of the paper. Then I painted cobalt blue and Prussian blue around it. Mixes of ultramarine blue and crimson were then applied, followed by combinations of orange, Prussian blue and crimson. Note that I applied the lightest colours first, working up to the deepest. The whole of the paper was covered by the sky. My final touch at this stage was to lift colour off using a soft tissue to form a horizon line. Remember that this can only be done while the paint is still very wet. I then let the painting dry.*

Step 2. *While the paper was still damp, I painted in the left-hand mountains using cerulean blue and some of the other colours used in Step 1. The right-hand headland was indicated using a mix of Prussian blue and crimson. Then I left the painting to dry.*

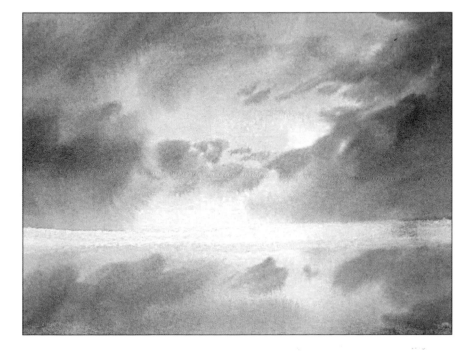

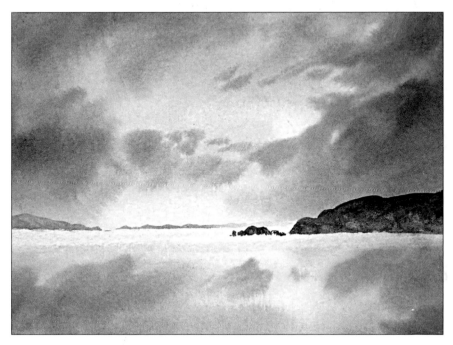

Step 3. *Using a mix of raw umber and Payne's grey, I painted in the sand and mud at low water. Using my dark colour mix of burnt sienna and ultramarine blue, I painted in the edges to the sand and mud and old timber posts. For the distant trees, I used a mix of burnt sienna and Prussian blue. Then I let the painting dry.*

Step 4. *I painted in the rock shapes using a diluted wash of my dark mix of burnt sienna and ultramarine blue. Then I indicated the sea colour with a very diluted mix of yellow ochre and Prussian blue. I let the painting dry. Then, using a large brush and a thin mix of ultramarine blue and crimson, I applied a purple glaze across the foreground and the middle distance. The painting was left to dry.*

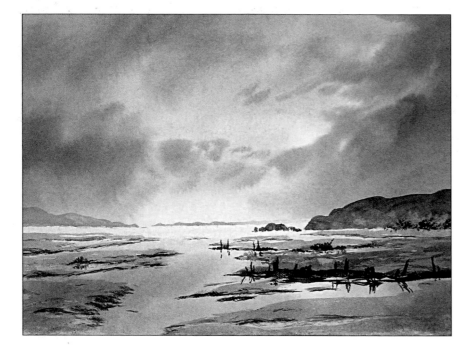

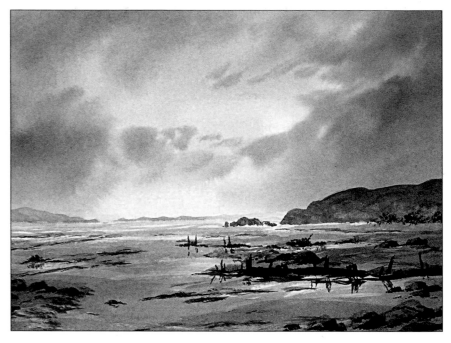

Step 5. *My final touches were to paint some dark birds into the sky using my dark colour, and a few light ones using a little white gouache. I also used this colour to paint in a small white boat in the middle distance. The painting was now complete and was left to dry.*

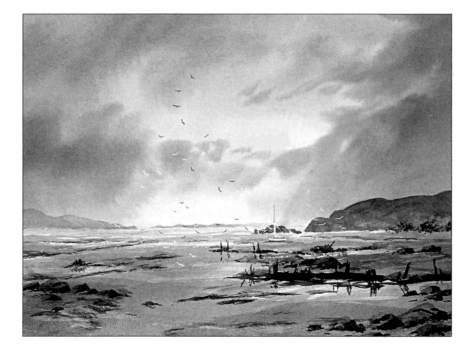

One of the things that I tell my students on a regular basis is this: if you are between paintings, or simply don't feel in the mood to produce a finished painting at that moment, why not paint a sky? I do this quite often, and I find that I gradually build up a varied collection of sky studies, just waiting to be introduced to a landscape! I really do find this way of painting to be great fun.

Because I enjoy this method of painting so much, I have decided to include a few more examples from my collection here. I will also explain to you how I decide which landscape will fit a particular sky and how I set about painting it. If I have not predrawn a composition onto my watercolour paper, I simply paint in a sky and let it run down the slope of the paper. As it starts to dry, a variety of shapes start to appear, which might resemble, for example, distant trees or mountains. I use this technique when I demonstrate to art societies and like to refer to it as 'letting my painting talk to me'. I believe that my technique of painting skies will allow the painting to suggest what it wants to be. All of my small cameo paintings are painted in this way.

Now let's look at some sky studies. The painting technique remains the same as I have outlined. Remember to pay special attention to my small cameo paintings throughout the book.

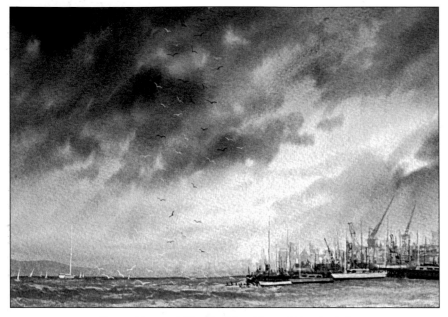

Boats, Sea and Clouds. 28 x 38 cm (11 x 15 in.)

I included this painting to make the following point: if you have got a very strong sky, you can have a simple landscape. In this scene the landscape covers only a small proportion of the paper, yet I feel that it looks quite balanced and just about tonally correct.

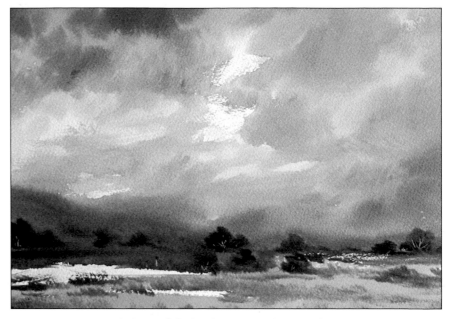

Peace and Quiet. 28 x 38 cm (11 x 15 in.)

I really enjoyed painting this scene. It is one that came straight out of my mind, with no drawing or planning. I painted the sky in very quickly on to wet paper, using a large brush. The colours were cerulean blue, cobalt blue and Payne's grey. The distant mountains were lightly painted in using cobalt blue and crimson while the paper was very wet. As the paper began to dry, I painted in the middle-distant hills using yellow ochre, lemon yellow and Prussian blue. The rest of the landscape was completed using varying mixes of the above colours before the paper had dried. The water was left as the white paper. There are no hard edges, and the painting was painted in 15 minutes. These types of paintings are very often the best.

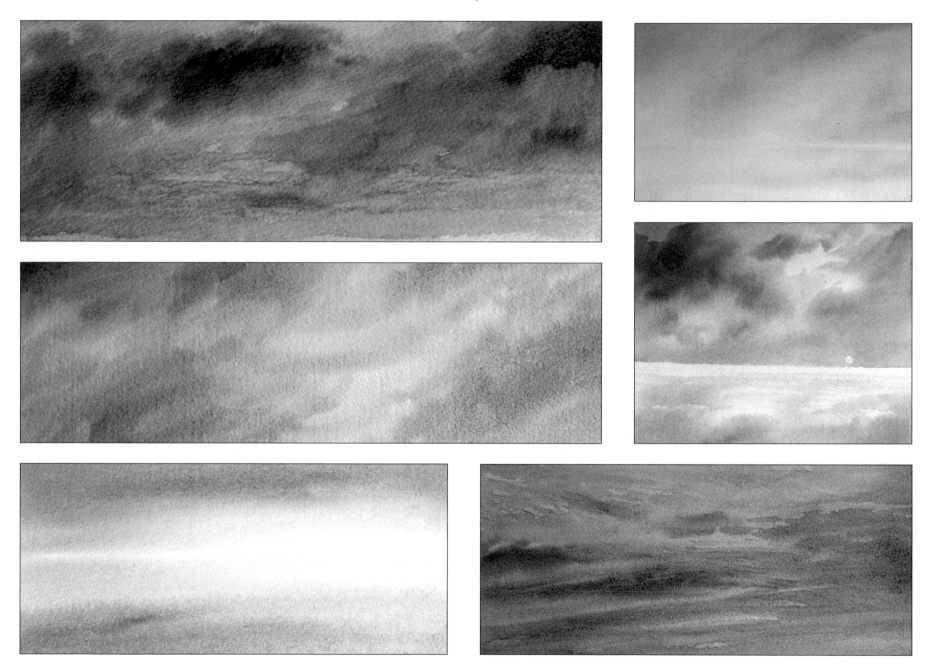

Gallery of Skyscapes

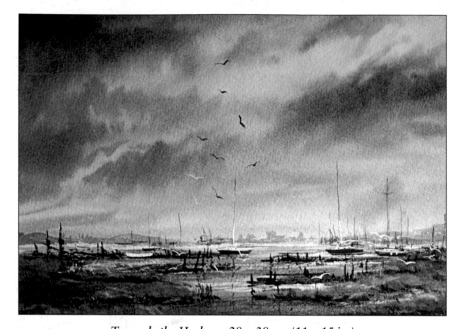

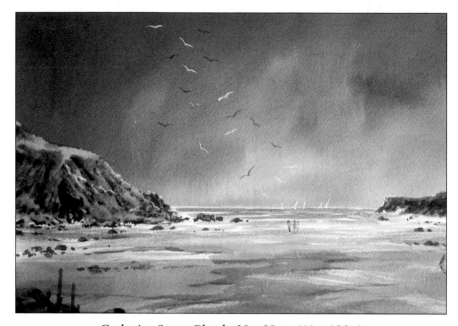

Towards the Harbour. 28 x 38 cm (11 x 15 in.)

Most of my skies cover approximately two thirds of the paper because
I believe that the sky is the heart and soul of your painting. It creates the mood
and atmosphere, and makes the painting come to life. In this composition, it
suggested a sunny day with a little wind. I loved the way that the sun was
shining on the middle-distant sand and grass, and this was complemented by
the foreground shadow. I painted the dark posts, masts and birds, etc. in contrast
to the lighter background, and the boats added another point of interest.

Gathering Storm Clouds. 28 x 38 cm (11 x 15 in.)

This scene was lit by the most magical, almost eerie, type of light. On the one
hand, you had the wonderful reds, pinks, purples and blues of a coming sunset,
and on the other you had the brooding, heavy blue-grey storm clouds. It was
bright with a scattering of cloud shadows cast across the beach. The two distant
figures added a sense of scale to this magnificent scene. In the distance the sailing
boats leaned into a strong wind, and the sea was breaking against the
middle-distant cliffs. I sat for a while, gazing at the scene in both awe and
admiration. What a test for any artist!

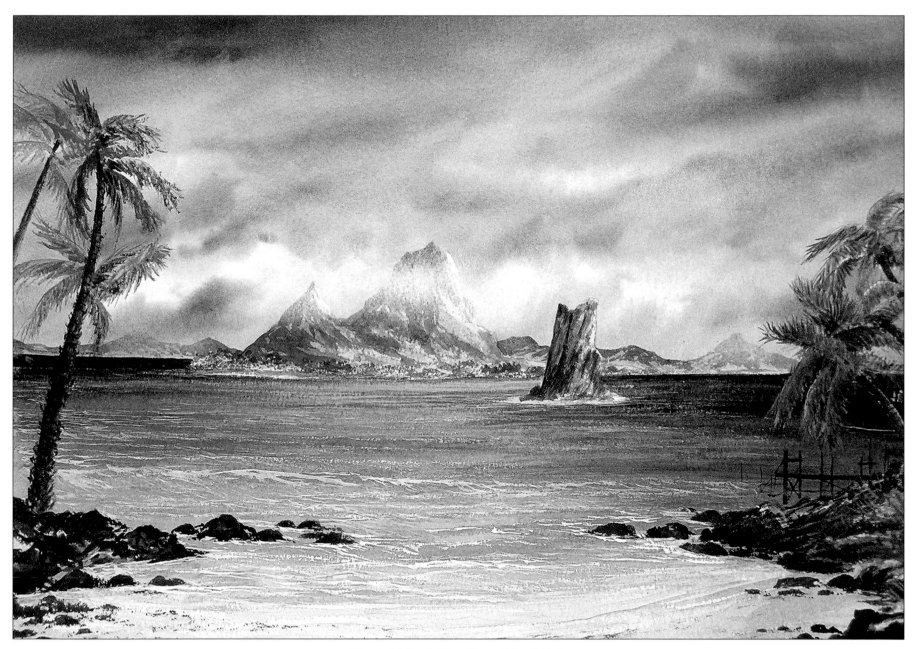

Tropical Island. 28 x 38 cm (11 x 15 in.)
This was produced for an exhibition at St David's Hall, Cardiff.

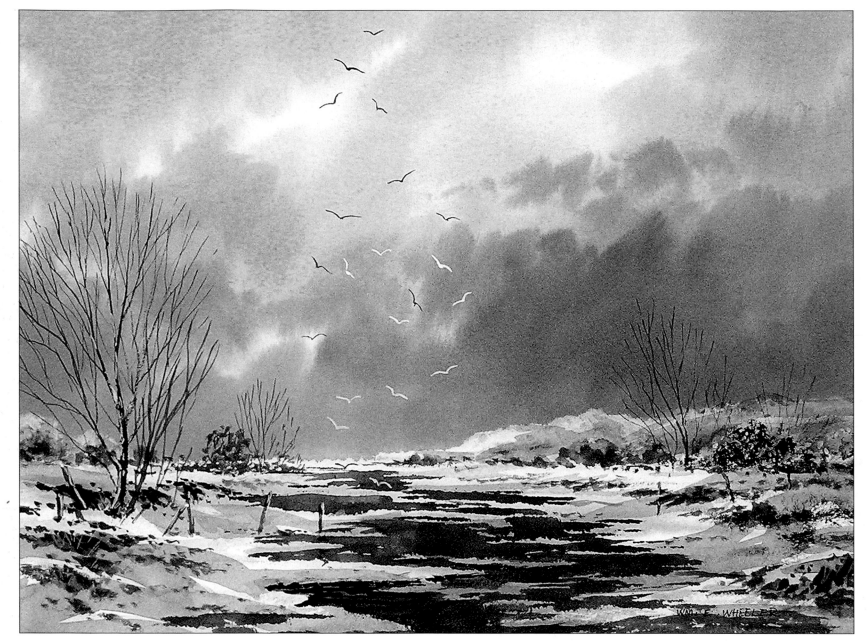

Approaching Storm Clouds. 28 x 38 cm (11 x 15 in.)
This type of subject in winter – the sense of coldness and an impending storm – is just made for painting in watercolour.

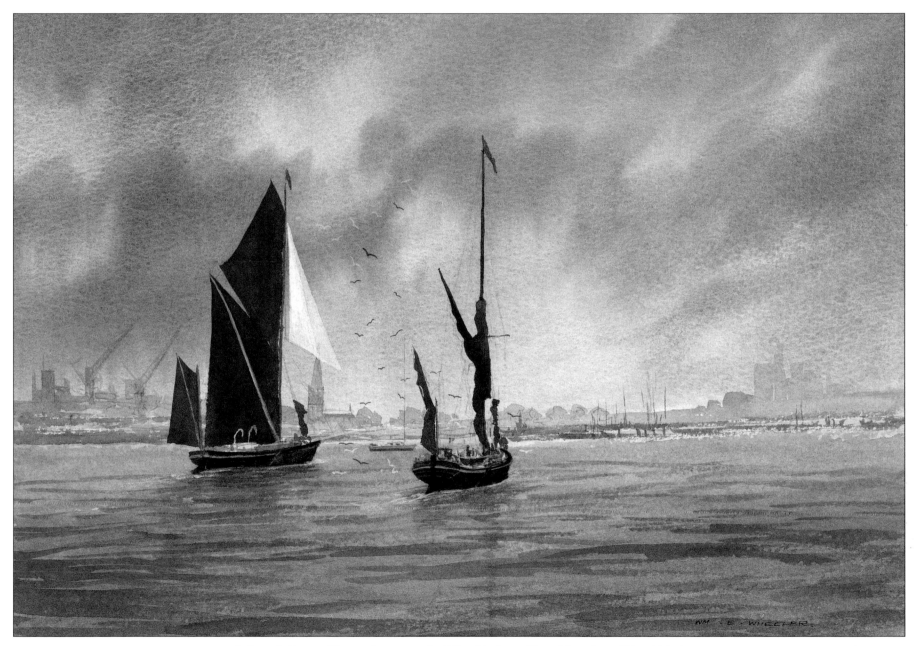

Before the Race - Thames Barges on the River Medway, Kent. 28 x 38 cm (11 x 15 in.)

Painting mountains

I have to admit that mountains play an important part in my world, both in my work as an artist and in my everyday life. Living in Wales, I am surrounded by them. I also live on the side of a mountain, so you could say that they are an intrinsic part of my existence.

When we talk about painting mountains, we must also think of the variety of visual illusions that distant, middle-distant, and foreground mountains might present to us, together with some technical problems, when we start to paint them. Let's look at these factors in more detail.

Distant mountains

You are probably aware that distant objects appear to look bluer the further away they are. We call this illusion colour or atmospheric perspective. Blues and other cool colours make objects appear to be further away. Reds and other warm colours make objects appear to be closer to you. Let's say that you wanted to paint in a distant range of low hills. You could use a thin mix of cerulean blue, or perhaps a thin mix of cobalt blue and light red.

There is a technique that I use to create the impression of soft, hazy, distant mountains. The technique is to paint in the mountains before the sky is completely dry. This method is a little difficult because you have to know the moment when you can safely paint the mountains onto the damp paper. If the paper is too wet or the paint is too thin, the colour will spread over the surface of the paper, spoiling the effect.

So there are two things that you must learn to judge in order to be successful in using this technique:

- the time when the paper is dry or wet enough to apply further colour; and
- the consistency of the paint in relation to the wetness or dryness of the paper.

Before you will be able to use this technique with confidence, you first have to master these two points. To master the technique, you must practise as often as you are able. With experience, the technique will become second nature to you.

Middle-distant and foreground mountains

I find the technique I use to paint middle-distant and foreground mountains much more difficult to put into words than that used for painting distant mountains. This is mainly because no two mountains look the same but vary in shape, colour and texture. In order to obtain a realistic effect, it is necessary to simplify. Each artist will have their own painting technique for depicting mountains – my method is to study the mountain shapes before I put pencil to paper. I look at rock structures, scree channels (these are formed over many centuries by water running down the mountain face), vegetation, colours and tonal values. I usually start to paint mountains with the application of a purple blue wash to the mountain top. While this is still wet, I often like to create the effect of mist by removing some colour with a damp brush or a soft tissue. Before the wash has dried completely, I apply glazes of yellows, greens, burnt sienna and purple to the rest of the mountain, letting the colours flow together to form a variegated surface colour. When this is almost dry, I will indicate ground movement, rocks and other textures, using a dark colour mixed from burnt sienna and ultramarine blue. Foreground mountains should be painted slightly stronger than those in the middle distance. Look for colour variation in different mountains.

To make my technique for painting mountains clearer, I have decided to include the following step-by-step demonstration, for which I have selected an interesting mountain scene at the Gap of Dunloe in Ireland. It contains many of the problems that you may come across. You will also find many other mountain scenes throughout this book, which I hope you will analyse and enjoy.

Step 1. *First I drew out my composition onto 250 lb Saunders Waterford Rough surface watercolour paper using a 2B pencil. I wet my paper with clean water and quickly painted in my sky using Prussian blue, cobalt blue, Payne's grey and raw sienna. Next I painted in my distant mountains before the sky had dried completely, using cerulean blue and Payne's grey. I then started to paint my main mountain using washes of burnt sienna, ultramarine blue and crimson. The painting was then left to dry.*

Step 2. *I began to paint in the rock and cliff details using a diluted mix of burnt sienna and ultramarine blue. Then, using glazes mixed from lemon yellow, burnt sienna, raw sienna and cerulean blue, I started to paint in the rough grass areas. I then painted in a dark purple-grey onto the left-hand mountain and let it dry. The purple-grey colour was made from a mix of ultramarine blue, crimson and Payne's grey. I then applied glazes of burnt sienna, lemon yellow and Prussian blue to indicate grass, etc. The painting was then left to dry.*

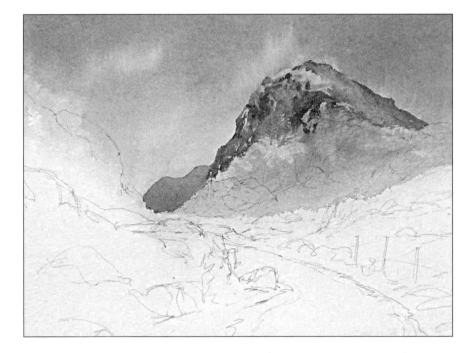

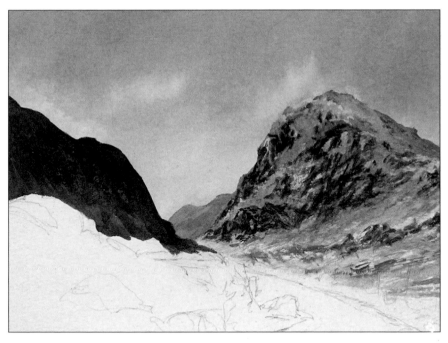

Step 3. *Using glazes of lemon yellow, cerulean blue and burnt sienna I enhanced the colours of the grass areas in the middle-distance. I then painted in a cool, grey colour mixed from light red and cobalt blue on to the road area. Using my dark colour I painted in the shadow area of the near, left-hand rocks. The painting was then allowed to dry.*

Step 4. *I painted in shadows on the rocks and mountains using a purple glaze mixed from ultramarine blue and crimson. Using the range of colours I used in Step 2, I painted in the grass, etc. in the left-hand foreground area. When this had dried a little, I indicated the edge of the road using raw umber and ultramarine blue. The painting was then left to dry.*

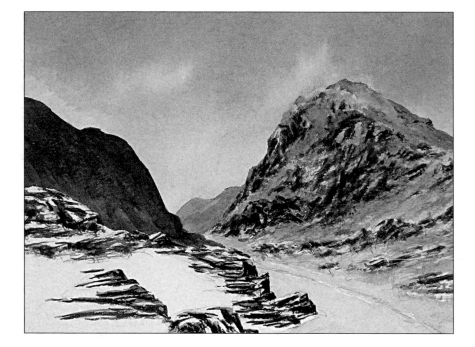

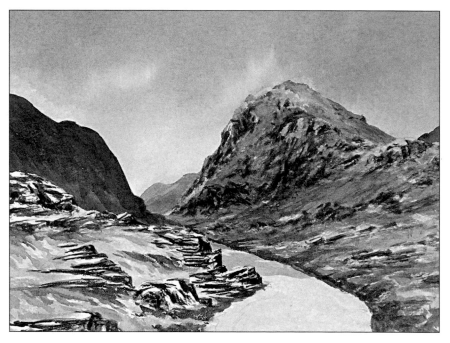

Step 5. *Using my purple mix, I painted in cast shadows across the foreground grass, rocks and road. I strengthened the colour at the edges of the road and indicated a few fence posts and the birds in the sky, using my dark colour. I then let the painting dry.*

Step 6. *My final touch to complete the painting was to use a wet natural sponge to remove some colour from the tops of the mountains to create a greater effect of mist. I then let the painting dry.*

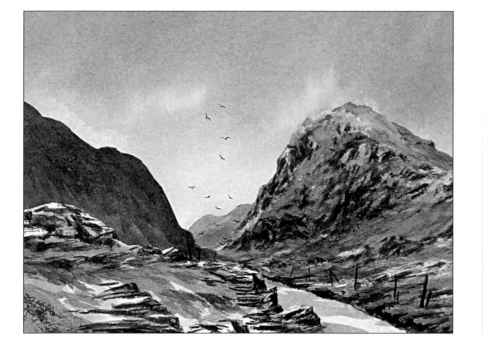

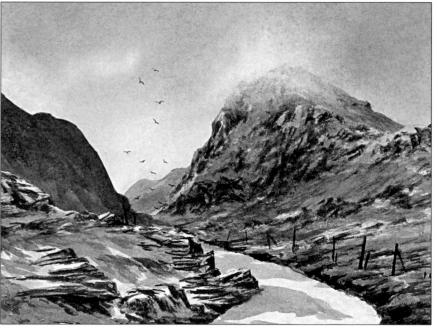

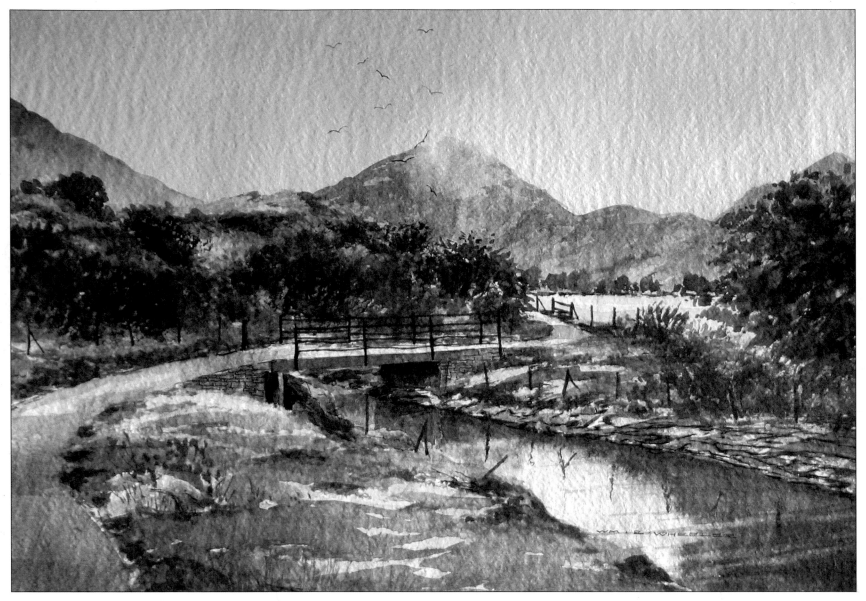

Up in the Mountains. 28 x 38 cm (11 x 15 in.)

I was very attracted to this North Wales landscape. It contains all of the elements which could create problems for most inexperienced landscape artists, but it is a very exciting composition to paint. Why not try to paint it yourself as an exercise? Before doing so, I would suggest that you spend a little time analysing it to see if you can work out my formula for painting it.

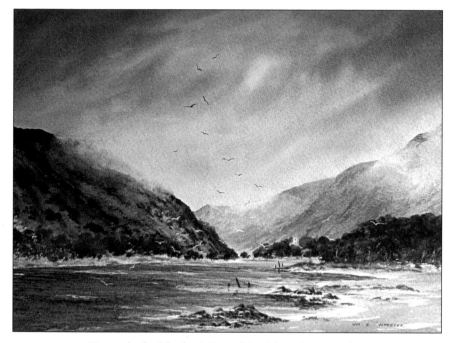

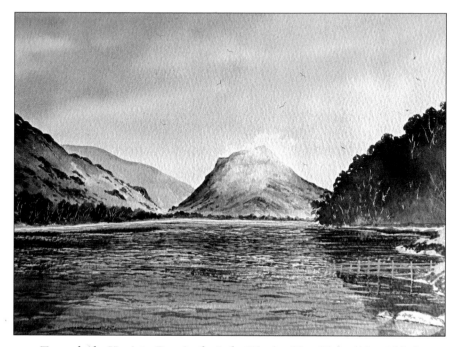

Towards the Llanberis Pass. 28 x 38 cm (11 x 15 in.)

I did this painting as a demonstration for an art society. It was based on details from one of my sketch-books. I am a firm believer in the use of a sketch-book, and I encourage all of my students to keep one and use it at all times. I like to refer to sketch-books as artistic diaries, because they do really become day-by-day records of your artistic endeavours. I love painting mountains, and this painting with the tops shrouded in mist is full of atmosphere and a sense of solitude. This simple scene is similar to many others found around the country. As artists we are fortunate to be able to select a scene, enjoy it and record it onto paper for other people to enjoy.

Towards the Honister Pass in the Lake District. 28 x 38 cm (11 x 15 in.)

Over the centuries, the Lake District has attracted artists, poets, writers, photographers, walkers and climbers. It is a place of unspoilt natural charm and beauty. I have not spent a great deal of time there but enough to make me want to return as soon as time allows. Just seeing this view was a magical experience and I knew that I simply had to paint it. Because of lack of time, I made a coloured sketch, took some photographs and painted the scene back in my studio.

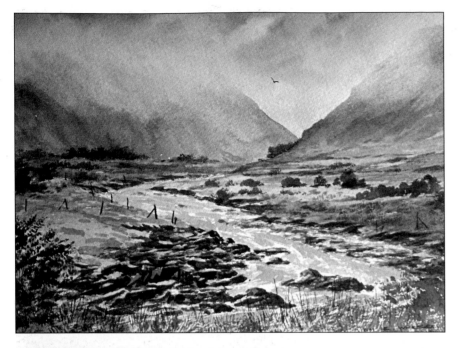

Glencoe, Scotland. 28 x 38 cm (11 x 15 in.)
I would like to think that this view of the high mountains covered in mist, the rough pasture land, rocks, bushes and the tranquil stream will create a sense of Scotland in the eyes of the viewer, and if this is so, then the painting is successful. We as artists must learn to look at a scene and acquire that gut feeling of knowing that it will make a good painting. Never start painting the first composition that you see. Walk around and look at your subject from as many angles as possible. Then, and only then, should you select your preferred composition and start to draw.

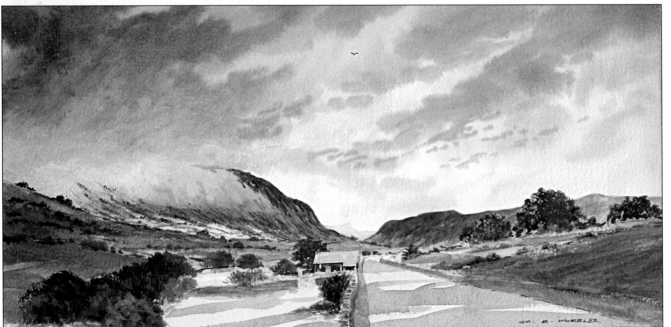

Toward Tryfan Mountain, North Wales.
28 x 38 cm (11 x 15 in.)
This is a very popular walking and climbing area. I try to do some painting here whenever I am in the area. This time, I just couldn't resist the lure of the atmospheric blanket of mist on top of the mountain.

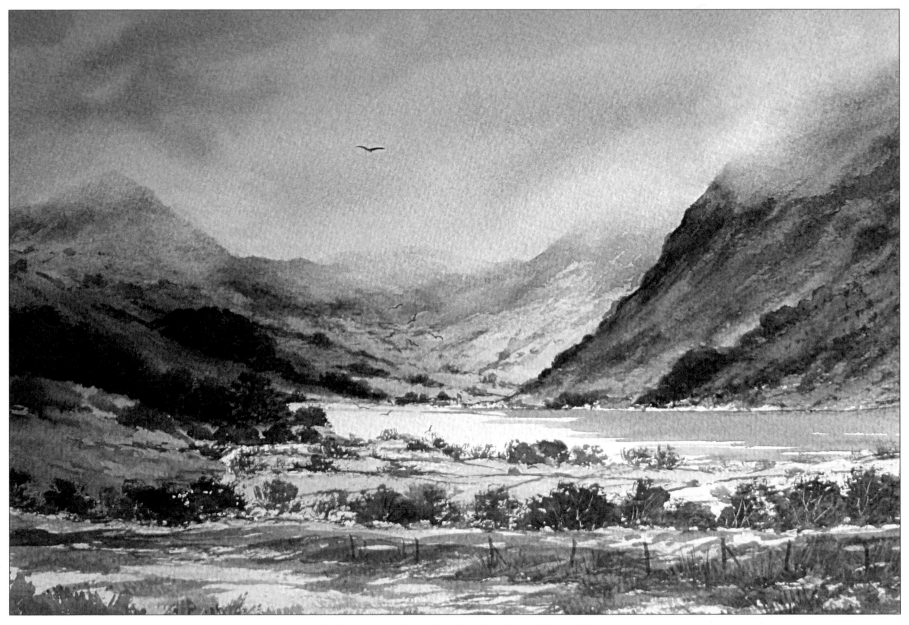

Lake Buttermere, Lake District. 28 x 38 cm (11 x 15 in.)
Painting in the Lake District is quite an experience for most artists, and I am no exception. It is like being let loose in an artistic
Aladdin's Cave – full of untold treasures. Why not try to paint this one yourself?

Here is a selection of my cameo paintings to illustrate my technique for painting mountains.

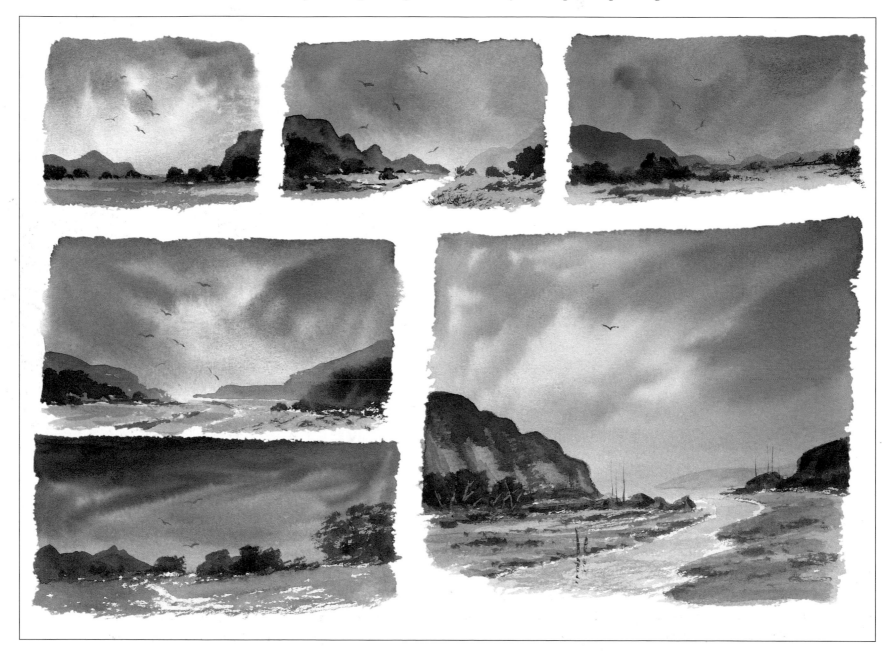

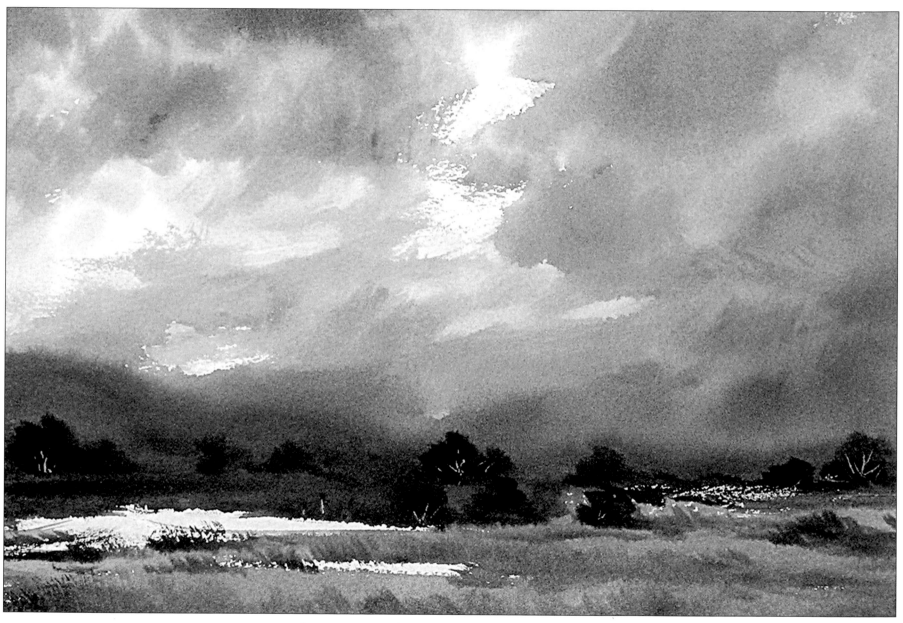

Blue Mountains and Quiet Waters. 28 x 38 cm (11 x 15 in.)

This painting was done as a demonstration to a group. The main point was to introduce them to the technique of painting from your mind – no pre-planning or drawing – and to the technique of painting wet onto wet. Note the impression of animals in the distant fields, achieved by using a dry brush technique on this particular area.

Waiting for the Tide. 28 x 38 cm (11 x 15 in.)
This painting was based on an existing sketch and done as a demonstration for an art society.

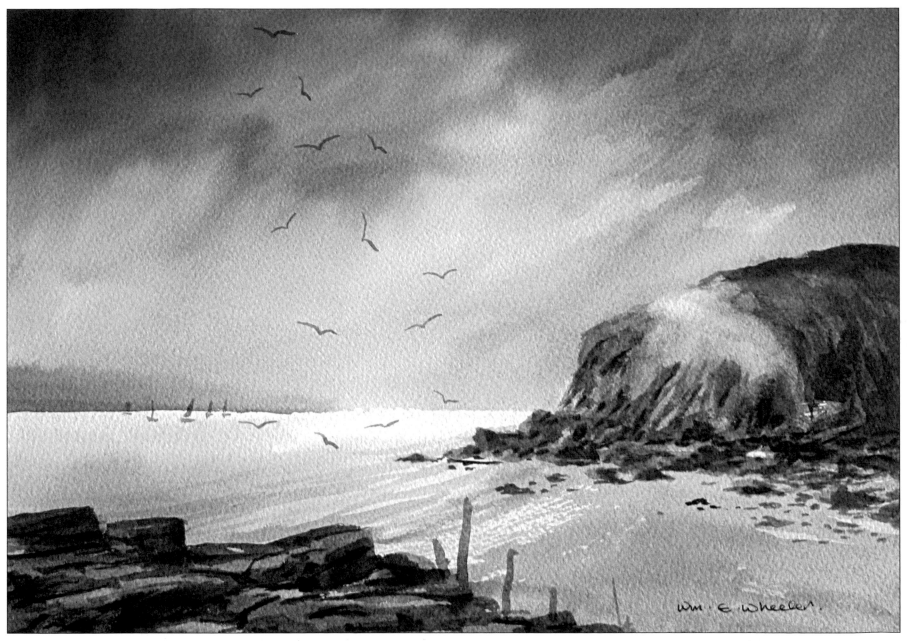

Beach Scene in Monochrome. 28 x 38 cm (11 x 15 in.)

One technique that will help you to understand tonal values a little better is producing paintings in monochrome. Why not try reproducing this one as an exercise?

Painting trees, foliage and grasses

The act of painting trees and grasses can often present the novice painter and sometimes the more experienced artist with quite an artistic minefield. This can seem very daunting, but I believe that the following information may alleviate some of the problems and help you to understand my personal approach to this particular subject.

> **The key to painting trees, foliage and grasses is simplicity! Keep everything simple and keep detail to a minimum. Just attempt to create an overall impression.**

The first thing that I would suggest that you do is study some of the most commonly seen trees. Make photographic studies of them whenever the opportunity arises and use these for reference. Start a sketch-book on trees and draw them as often as you can, until the act of drawing them becomes second nature. Study trees through each of the seasons. In winter, you are able to study the complete skeletons of trees, which in turn helps to make your task easier when you paint them in full foliage. Trees present the artist with a kaleidoscope of colours in every season – make a study of this and learn to use it.

After many years of teaching watercolour painting, I have lost count of the number of times I have had students ask me, 'Which is the best brush to use for painting trees?' Over the years I have used a variety of brushes in search of the answer to this question, and I think it is safe to say that it is not so much the type of brush that matters, but the artist's technique in using the brush, the consistency of the paint and the type of paper selected for this purpose. I am not saying that the brushes that are marketed as tree or foliage brushes are no good – most of them are excellent. What I am

saying is that, with a little knowledge and skill, you will be able to paint realistic trees and foliage with most of the brushes that you already have. We have already discussed in some depth the equipment and materials I use, but it might also be useful to examine some of them more closely and take a look at those I prefer to use for this particular task.

Brushes

The choice is very simple: my two selected brushes are a No. 6 Kolinsky sable rigger and a No. 8 round sable. With these two brushes, I am able to paint all of the types of trees that I encounter.

Colours

There is no easy way to become proficient in the mixing and use of greens and greyed harmonious colours. I have provided helpful tips for mixing greens on page 24 and for greyed harmonious colours but you have to spend time and practise. Any artist who is honest will tell you that one of the things that has given him or her problems over the years when working outdoors is mixing and using the greens he or she has been confronted with. The only way to learn is through simplification and practice, and working outdoors as often as you are able.

Paper

Both of the papers I have chosen to use throughout this book will be satisfactory. The Rough will help to provide texture and the NOT surface will allow you more scope for detail.

Paints

The colours I have selected should meet all of your requirements. You just have to decide which yellows and blues you would prefer to use for your greens, and then practise!

I think that it would be unwise of me to instruct that you should mix this blue with this yellow, etc. We all perceive colours differently, and as artists I believe we should arrive at our own conclusions. When you are starting to paint trees, however, my advice is to keep everything simple. Start with just a few colours and aim to capture an impression of the tree shape that you have chosen to paint. Do not try to include too much detail.

The type of trees I have chosen to include here have been used because I like their shapes, colours and their positions within the compositions. Throughout this book I will be showing my techniques for painting a variety of different types of trees, both isolated and in groups. The method of working I want to demonstrate will be the one that I enjoy using when working outdoors in the field. I hope that this approach will be more useful to the less experienced artist.

During my demonstrations to art societies and groups around the country, one question I am asked time and time again is, 'What type of tree is that?' My answer is usually, 'Will knowing the type of tree make your painting any better?' It might be more useful to concentrate on the technique that I use to paint trees. Let me hasten to explain! I am not saying that it would be a waste of time to learn the names of the different types of trees that you may encounter on your travels as a landscape painter. It could be very useful, and sometimes essential, to be able to recognise the various types. Very often, however, this knowledge makes no difference to the quality of the completed painting. There are times when, whilst working outdoors, you will choose a composition containing so many trees that it will be impossible to identify each one. On occasion, you may come across a scene that you would like to paint that contains only a few particular tree types. It is at times like this that knowledge of the different types of trees could prove to be very useful. It is sometimes more beneficial to develop a technique which will enable you to depict any number of different tree shapes, in any location, and in any season.

If you observe your scene carefully and draw in the detail that you require, you can always find out the name of a tree at a later time. There are many excellent books on trees available in the shops. A small, pocket-sized book could prove to be a sound investment. I carry one with me whenever I am out painting.

Before we move on to study trees in greater detail, I would like you to try this exercise. You can often identify a particular tree by its silhouette. Let's look at a scene to see if the idea works in a painting.

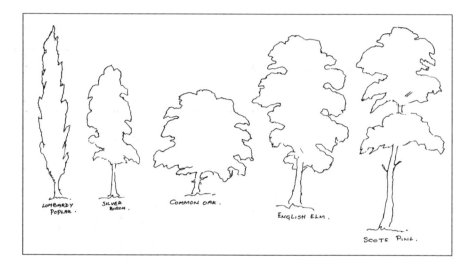

Select and draw out simple outlines for several tree types.

Draw out a scene in outline, drawing in each of the tree shapes and making sure that they are in perspective (i.e. the further away they are, the smaller they should be.) Then colour in the tree outlines using an opaque colour.

Look at my painting on page 78 to see how you can apply what you have learnt in this exercise in a practical way.

Why not try a few compositions of your own? Do not paint in the complete landscape – just paint the tree shapes and leave the rest of the scene in lines. This technique could be very useful to you and with practice you will start to achieve success in painting and creating compositions with trees.

After tutoring watercolour classes for many years, I am still amazed by the number of times that I have seen a very basic mistake being repeated by different students in different parts of the country when they start to draw and paint trees for the first time. Each time I start a new course in landscape drawing and painting, I usually commence the session by doing a quick demonstration so that the students can see the way I work. After this, I often ask them to draw a simple tree shape.

This is very often the result.

Of course, no one can say to a student with any degree of certainty, 'That does not look like a tree!' It may not fit the way that we think trees should look, but there may very well be one like it around the corner. In general, though, the following tips will help you to avoid drawing trees that look wrong.

There is no magic formula for drawing and painting trees, but observation, good drawing and of course good technique are essential to acquire a good foundation on which to build. The best time to study trees is in winter, when the lack of foliage enables us to observe the complete skeleton of the tree. At this point, it would be a useful exercise for you to draw a simple tree shape in a series of steps, following the guidelines below.

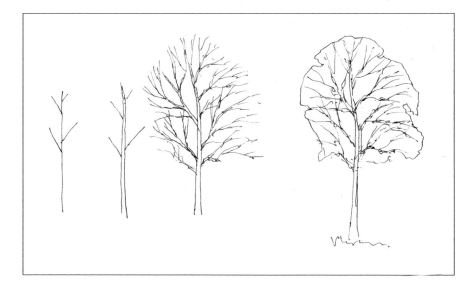

Drawing a tree – a step-by-step demonstration.

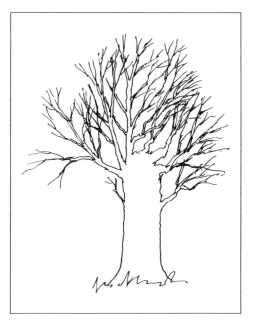

If we look at a tree in its simplest form, we have the main trunk, the secondary trunk, branches and twigs. The further away the branches are from the main trunk, the thinner they get.

Using a fine pen and a good quality cartridge paper, try drawing a number of different tree shapes.

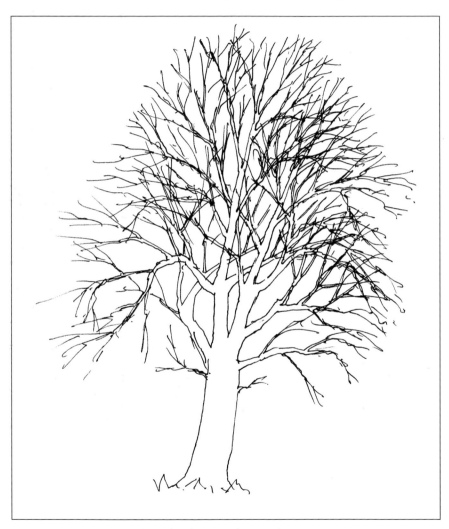

Ink study of a tree, done on location.

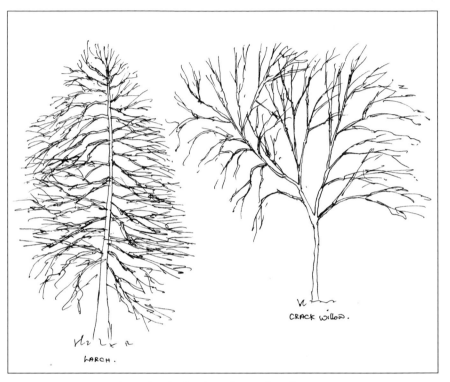

Ink study of a larch and a crack willow tree.

Now I would like to present a step-by-step demonstration, showing my way of painting trees in the landscape, in order to reinforce some of the points we have already covered.

Step 1. *First I drew the outline of my composition using a 2B pencil on 200 lb NOT surface Saunders Waterford watercolour paper. (For a discussion of the different grades of pencil and types of watercolour papers, see pages 19 – 20.)*

Step 2. *Next, I wet the sky area with clean water and painted in the sky and distant mountains using cerulean blue and ultramarine blue. While the paper was damp, I painted a base coat over the landscape area using aureolin yellow and yellow ochre, except for the path. Using various mixes of aureolin yellow, yellow ochre, Payne's grey, ultramarine blue, Prussian blue and burnt sienna, I painted in the distant trees. I then let the painting dry.*

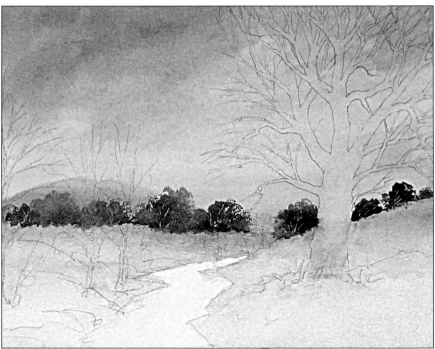

Step 3. *Using the above colours, I continued to add tone to the distant trees, and painted in the middle-distant trees and the rest of the grass areas. The painting was then left to dry. Remember that because watercolours dry approximately 50% lighter, it is very important to let the work dry completely before proceeding to the next step.*

Step 4. *I mixed a cool grey, using light red and cobalt blue, and painted in the colour to the path. Using my dark colour, I painted in the left foreground tree and the edges of the grass bank and path. The path had now dried, so using a purple glaze, I applied cast shadows across the path and grass areas. The painting was then allowed to dry.*

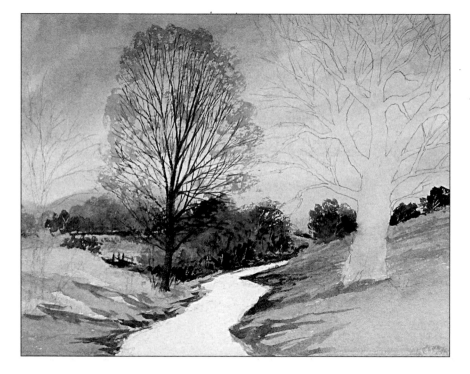 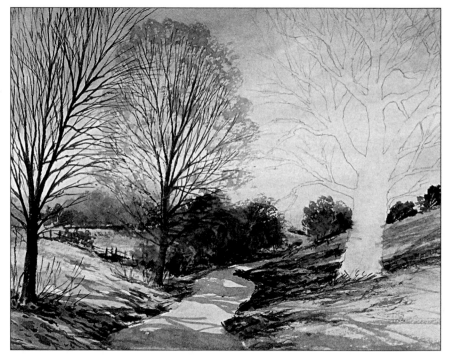

Step 5. *I started this step by painting a warm glaze on the fore-ground using burnt sienna. Then I started to apply a variegated glaze to the large right-hand tree, using purple and raw sienna. Once this colour had dried, I started to paint the whole of the tree, using my dark colour. Then I left the painting to dry.*

Step 6. *My final touch to the painting was to paint in three figures to add scale and also to bring a little bit of life to the work. The painting was now complete and was left to dry.*

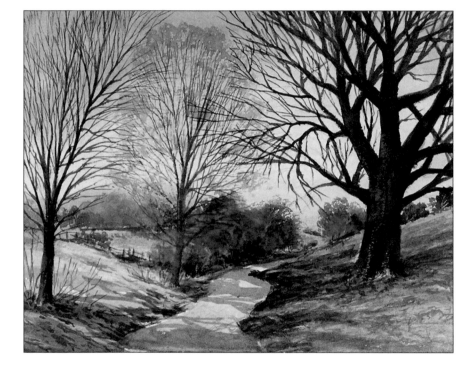

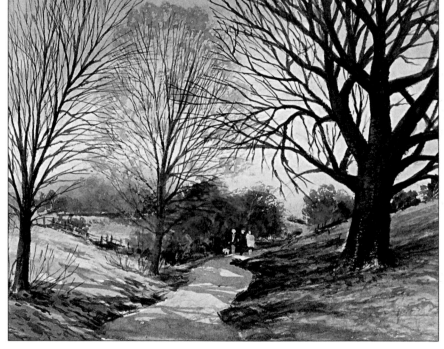

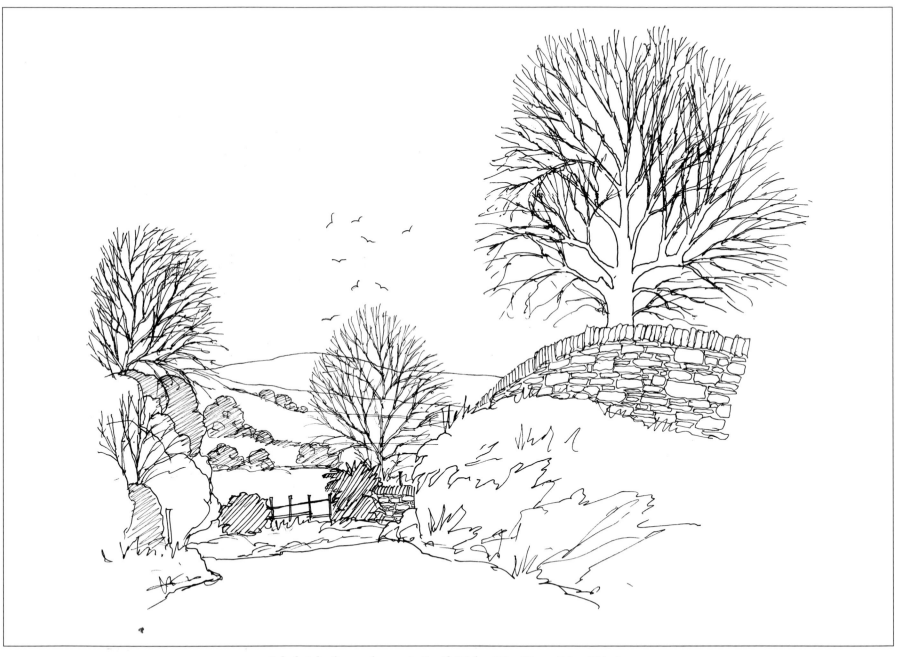

Ink sketch of a rural scene in South Wales. 28 x 38 cm (11 x 15 in.)

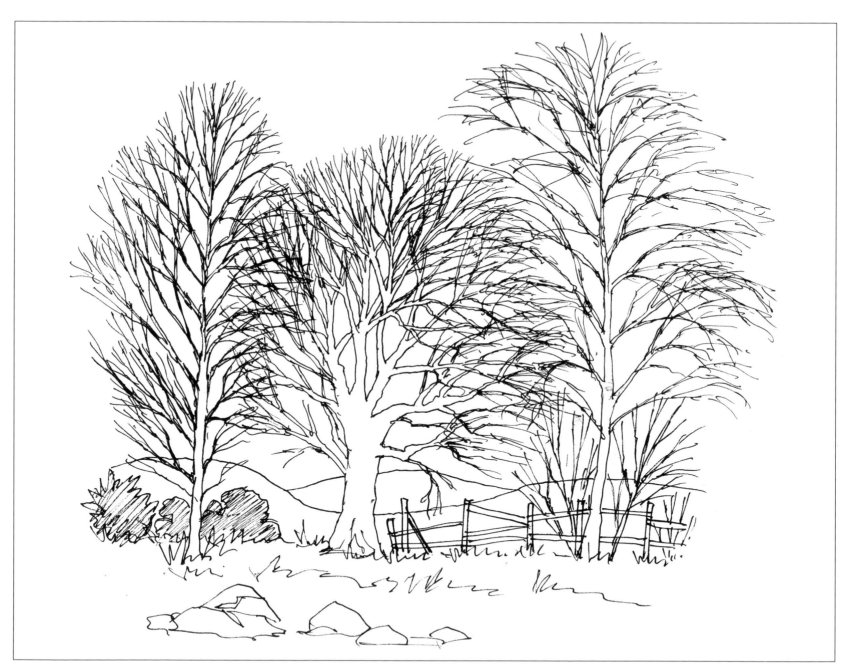

Ink sketch of three tree outlines. 28 x 38 cm (11 x 15 in.)

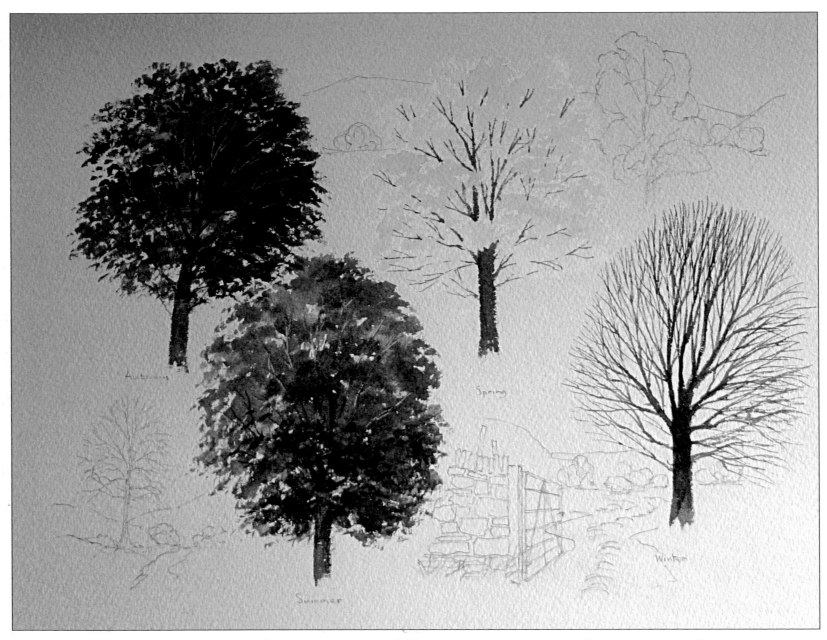

The above sketch shows the same tree depicted in all four seasons. It is most important that you make yourself
aware of how a particular tree looks in each season. Why not try this as an exercise yourself?

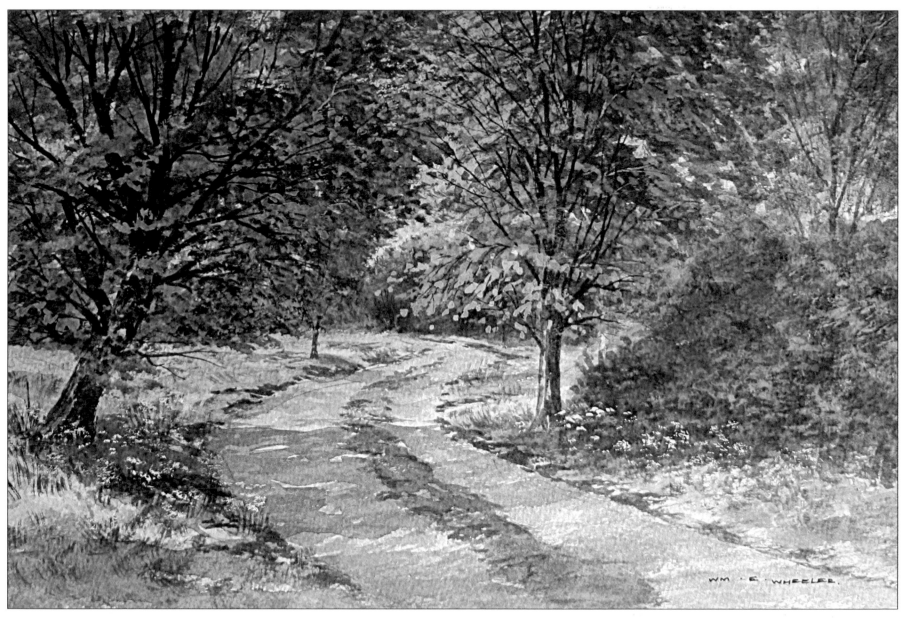

A Country Path. 28 x 38 cm (11 x 15 in.)

This scene was painted very near to my home and it is the type of scene that can be found in most parts of the country. It is a very simple type of composition but I would say that it is one of the most difficult ones to paint, mainly because of the wide variety of greens. This really is one that you should attempt as an exercise.

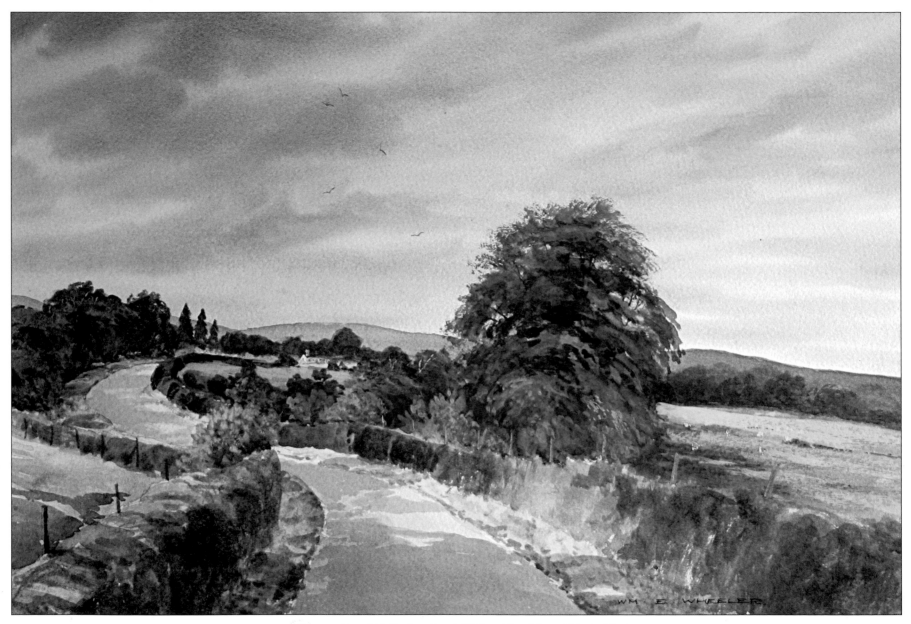

A Country Road Nr Rudry, South Wales. 28 x 38 cm (11 x 15 in.)

This was a ready-made subject just waiting for a landscape artist to come along, so I duly obliged. Any artist who finds mixing greens difficult and is looking for a subject on which to experiment, look no further. This should present you with all of the problems that will come your way, and all in one subject.

I am closing this section with a few of my small cameo sketches, showing trees in distant and middle-distant landscapes.
I hope that all of the information that I have presented to you in this chapter will make the act of painting trees very much easier.

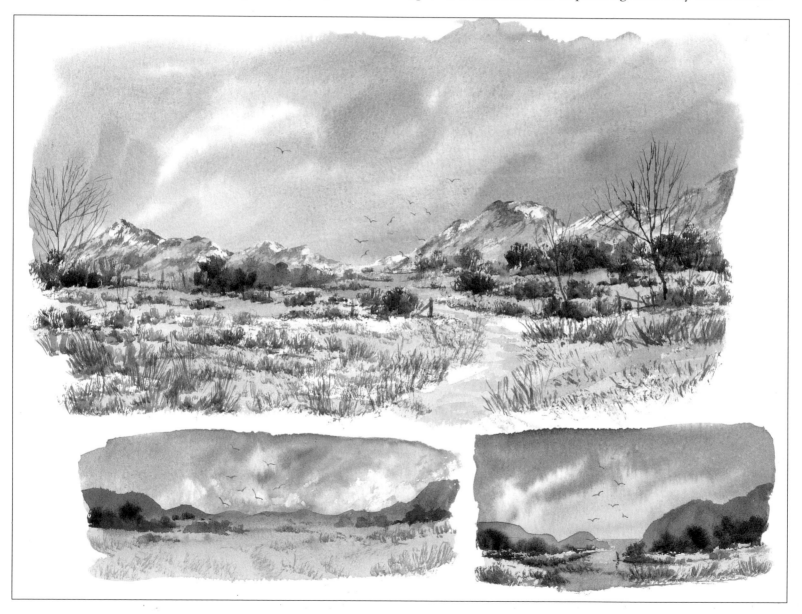

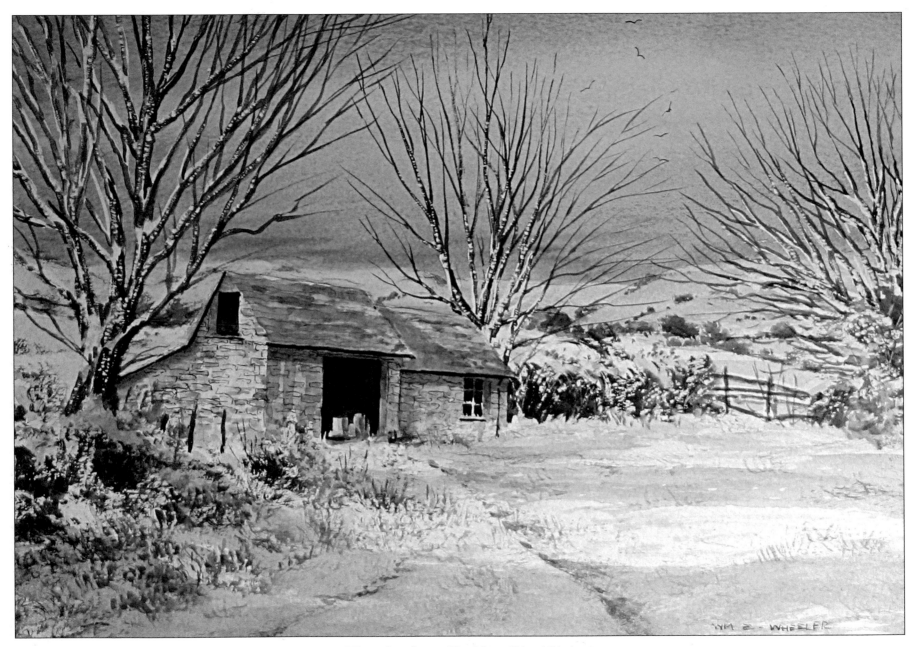

Winter Storehouse. 28 x 38 cm (11 x 15 in.)

During one of my days out sketching, I came across this delightful stone barn quite unexpectedly. It makes a perfect composition.

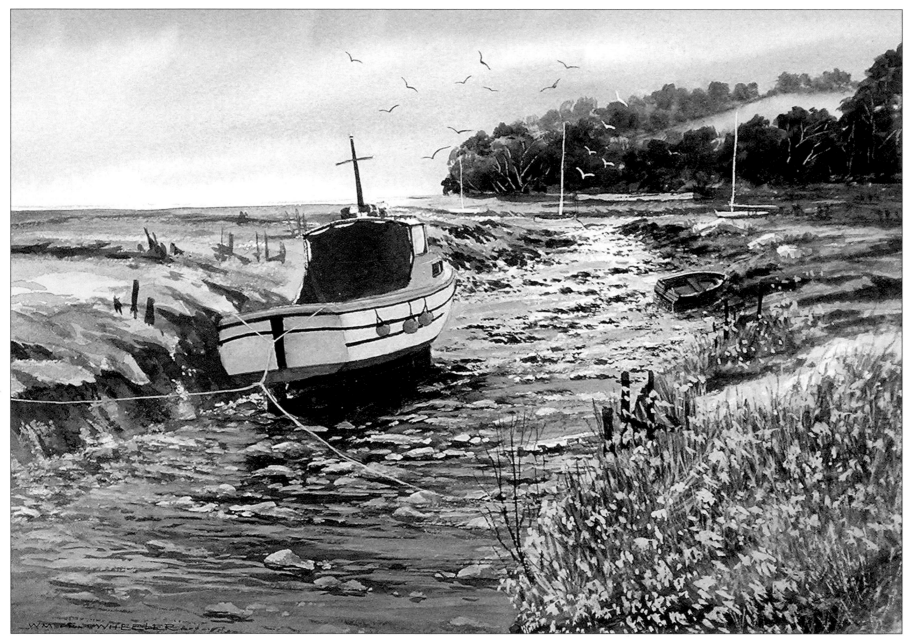

Low Water at Laugharne, West Wales. 28 x 38 cm (11 x 15 in.)

This is a very picturesque area to paint. It is called the Taf Estuary and is in the village of Laugharne, which was once the home of the poet Dylan Thomas.

Painting rocks and stone walls

One thing that I notice whenever I teach new students is their desire to produce a completely finished painting. This seldom happens, leaving the student both disappointed and frustrated. I can understand this, and usually I say to them, 'Forget the completed painting. Learn to paint the elements that make up the painting.' Before you can paint a forest, you have to learn how to paint one tree, and so on.

Rocks and stone walls fascinate me, and I like to compare them to props which are used in a theatrical show. They can dress up the production and bring it to life and they can also make or break it. They can in fact be some of the most important elements in a proposed composition.

Like other artists, I have my own particular way of creating the effect of rocks. I have found during my teaching sessions that many students will paint rocks using a brown colour and I am not sure why. So I thought it would be useful at this stage to describe some of the colour mixes that I use for painting rocks.

Greyed – not grey – colours, or harmonious colours, are some of the most useful colours to use in our paintings, and they are very simple to mix. Mix two colours, either red and blue or brown and blue, and the combination will produce a greyed colour which, when thinned with water, will give you lovely, harmonious transparent colours. These colours are very useful for depicting rocks and skies, etc. The overall mix, be it warm or cool, will of course depend on the quantities of each of the colours used. When blue is the predominant colour, the resultant greyed colour will be cooler, and so on. Only constant practice will enable you to make these judgements with ease.

In this section, using sketch details, I will introduce you to my technique of painting rocks and walls. On the whole, I do prefer using flat brushes when painting these elements and using pointed brushes when painting the joints, etc. However, I am sure that you could achieve the same effect by using any other type of brush, as long as you feel comfortable using it.

Why not attempt a few exercises using my technique – I am sure you will enjoy the experience. First, I will show you a step-by-step demonstration of painting a simple landscape containing these elements.

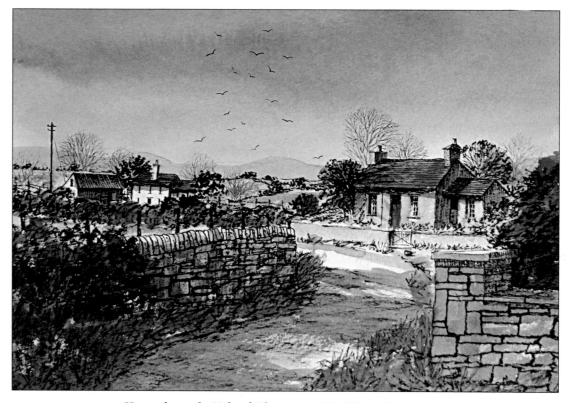

House down the Vale of Glamorgan. 28 x 38 cm (11 x 15 in.)

Step 1. *First I drew out my composition on Bockingford 140 lb NOT surface watercolour paper using a 2B pencil, which, I find, is the ideal grade of pencil for doing preliminary drawings. It is also a good idea to avoid drawing in too much detail at this stage.*

Step 2. *I started to paint the wall and rocks first, using glazes mixed from ultramarine blue, crimson, raw sienna, cadmium yellow, lemon yellow, cerulean blue and orange. First I applied a variegated wash to the dry stone wall, and indicated the grass at the base of the wall. Using a mix of light red, cobalt blue and yellow ochre, I mixed a greyed colour and painted in the shadow sides of the rocks. I then let the painting dry.*

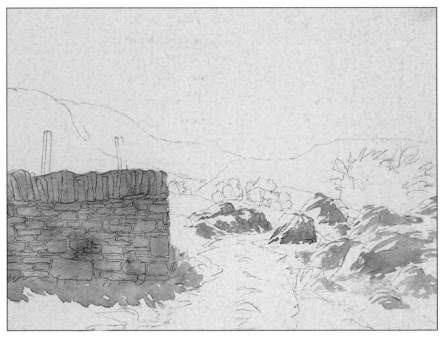

Step 3. *I painted in the sky, using Prussian blue and ultramarine blue. First I wet the whole of the sky area with clean water, and while this was wet I quickly painted in the sky. I let it dry a little, and then I painted in the furthest mountains using cerulean blue, yellow ochre and burnt sienna. The right-hand mountains were then painted using glazes of lemon yellow, cerulean blue and burnt sienna. For the left-hand mountain, I used the colours lemon yellow, Payne's grey, crimson and cadmium yellow. The painting was then left to dry.*

Step 4. *Using aureolin yellow, lemon yellow, cerulean blue and burnt sienna, I painted in the middle and foreground grass areas. Next, I applied glazes to the mountains using the above colours plus ultramarine blue and crimson. I painted in the middle-distant trees and indicated the hedgerows, etc. using cadmium yellow, Prussian blue and crimson. I applied a glaze to indicate the path, using raw sienna and light red. The painting was left to dry.*

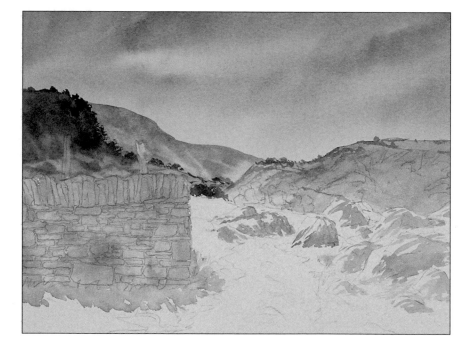 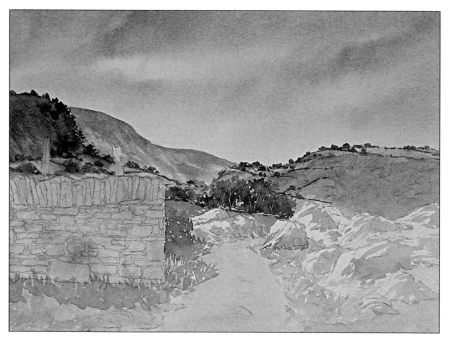

Step 5. *I began to add colour and texture to the rocks and areas of the stone wall using burnt sienna, ultramarine blue, crimson and raw sienna. Next, I painted in the strip of grass on the path using aureolin yellow and cerulean blue. Mixing a deep green with aureolin yellow, ultramarine blue and crimson, I painted in the tree behind the rocks. The light branches were lifted out with a knife before the wash had dried. Finally, I applied cast shadows across the landscape, wall, path and rocks, using a purple colour mixed with ultramarine blue and crimson. The painting was allowed to dry.*

Step 6. *Using my purple mix, I strengthened the cast shadow across the wall and foreground. Then, using a mix of raw umber and Payne's grey, I indicated the edges of the grass and the path. Using my dark colour, I painted in the joints in the stone wall. With a mix of raw umber and cobalt blue, I painted in the posts and birds in the sky. My painting was then complete and I left it to dry.*

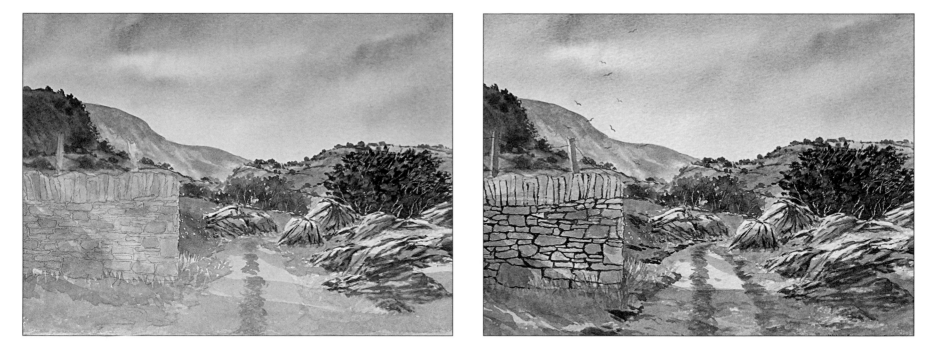

I have always found the painting of rocks and stone walls to be quite fascinating, and their inclusion in a painting can sometimes help to turn a weak composition into a much more successful one.

Study my paintings and take note of the number of times that they appear in my work. Here is a selection of my cameo paintings to illustrate my technique for painting rocks.

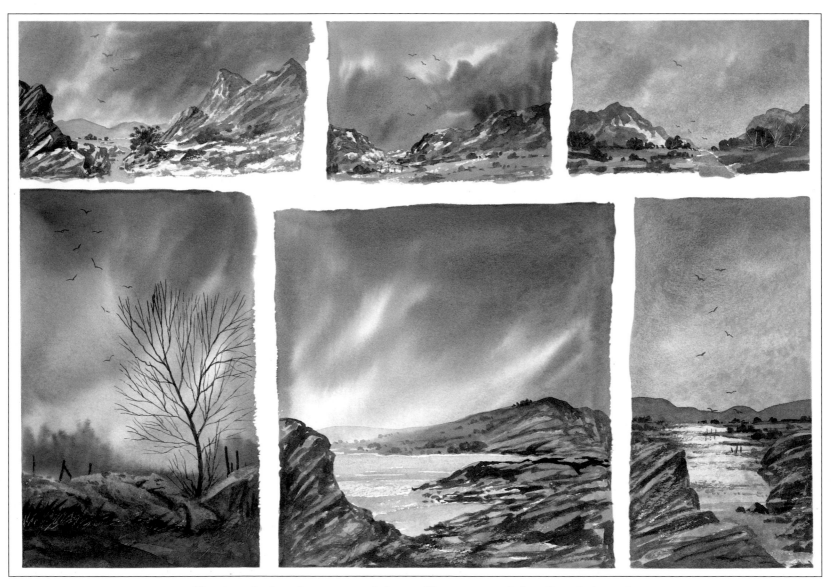

Here is a selection of my cameo paintings to illustrate my technique for painting rocks

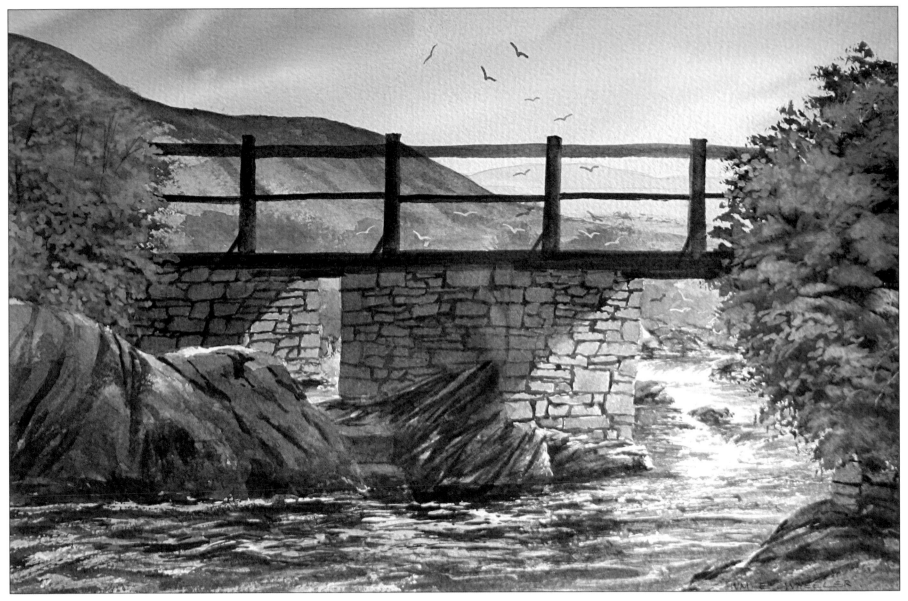

Old Stone Bridge, North Wales. 28 x 38 cm (11 x 15 in.)

There are many of these old stone rustic-style bridges to be found in Wales. Usually, if you come across one and take the time to look around it from different viewpoints, you will find that you have a composition from which you will be able to produce a good painting. When I come across something which I consider to be a little special, I usually mark it down on the map, with a view to making another visit in the future.

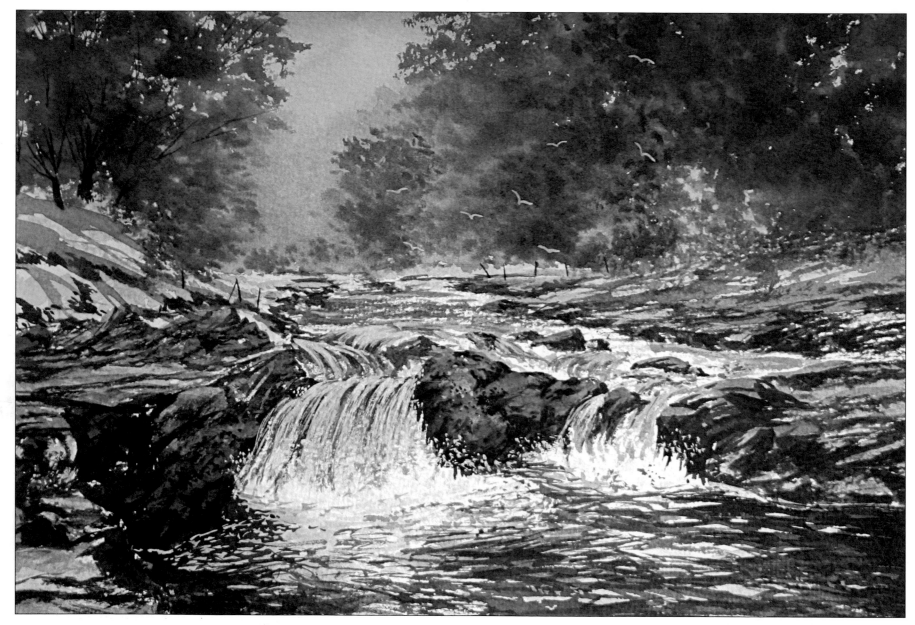

Waterfalls at Cray, Nr Brecon. 28 x 38 cm (11 x 15 in.)
This painting of these lovely falls was done in a location just before the river flowed under a very old drovers' bridge, but – as they say – that's for another painting!
I really enjoyed painting here – the colour of the rocks intrigued me.

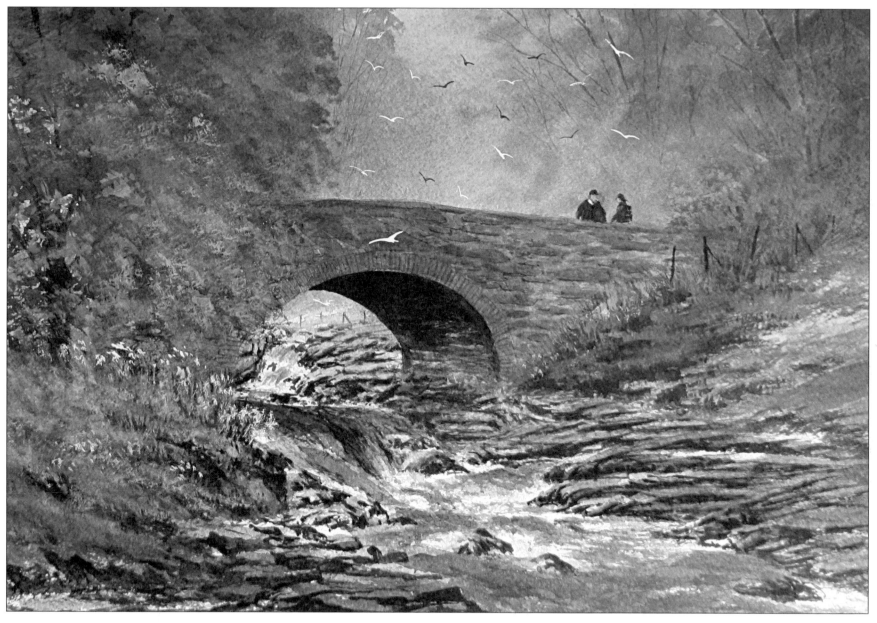

The Old Drovers' Bridge, Nr Llanbedr, North Wales. 28 x 38 cm (11 x 15 in.)
I would say that this very old, picturesque bridge is unknown to most artists. Those of us who have discovered it
and seen what a natural composition it makes should be truly grateful and just enjoy the thrill of painting it.

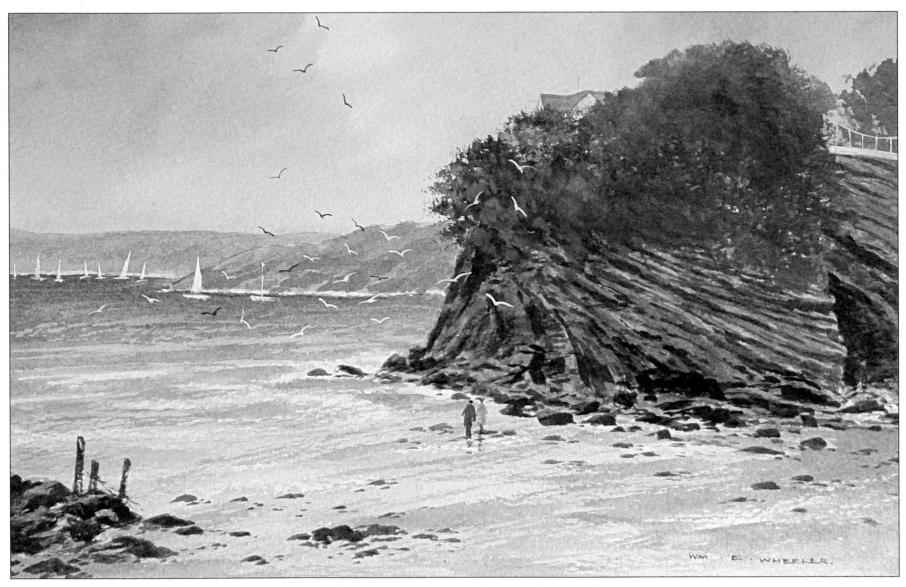

Beach Nr Newquay, Cornwall. 28 x 38 cm (11 x 15 in.)

The thing that attracted me to this delightful composition when I first saw it, was the unusual way that the rock structure had formed over the centuries. Also, the colours on the rocks were interesting to me as an artist. This little cove was oozing with character and atmosphere and just had to be painted. I was down in Cornwall running a watercolour painting holiday and the group was painting in Newquay. I did a few coloured sketches on this site and the painting was done as a demonstration back in our studio that evening.

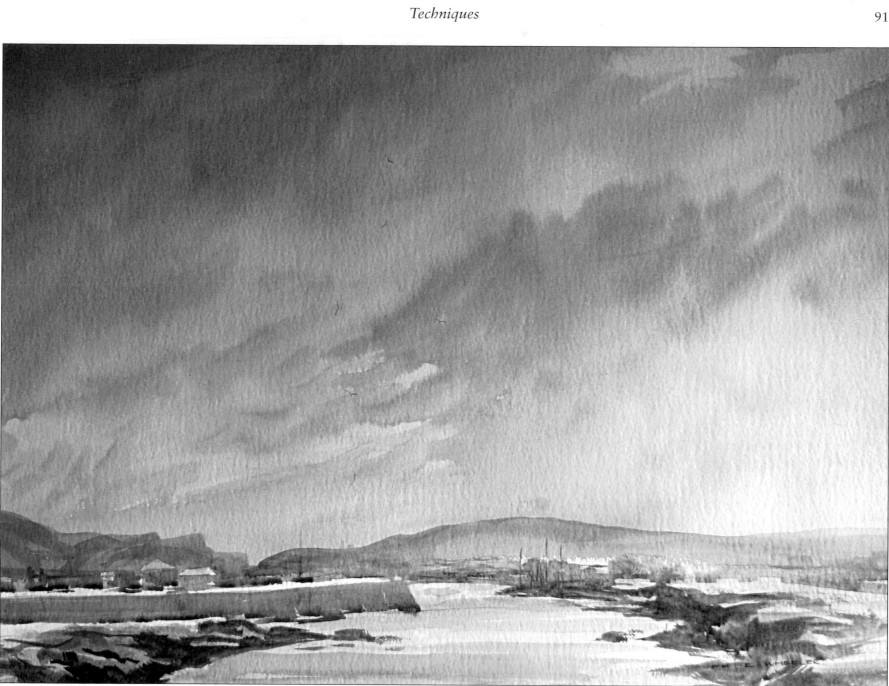

The Old Harbour. 28 x 38 cm (11 x 15 in.)

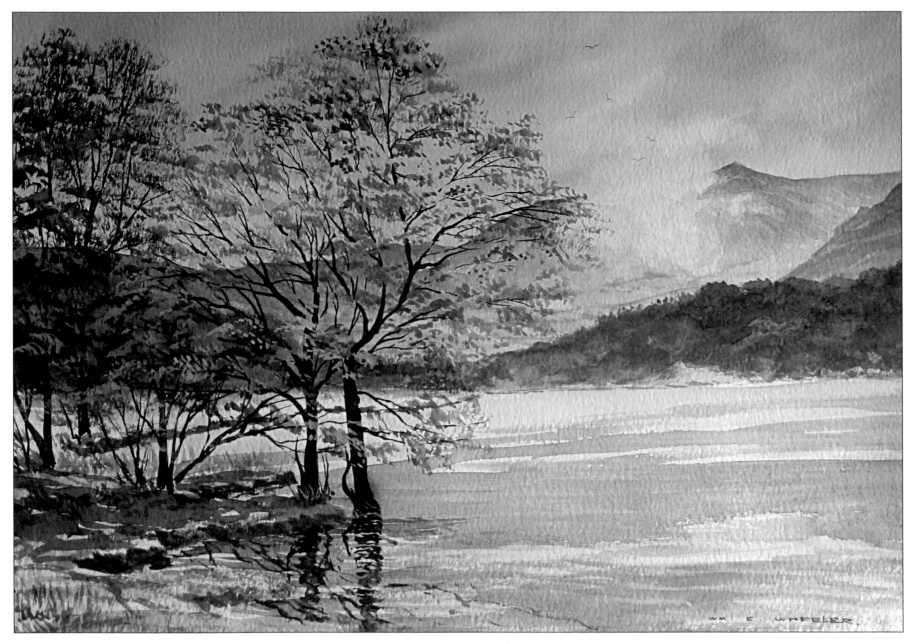

Llyn Nant Gwyn Nant, looking towards Snowdon. 28 x 38 cm (11 x 15 in.)

Painting water

Whenever I teach a group of new landscape artists, they are sure to ask the following questions: 'How do you paint water?' and 'What colours should you use?' My usual response is to ask the group the following questions:

What type of water do you mean? Is it placid water, as in a lake? Rough water? Running water? Is the water running fast or slow? Are you including a waterfall?
What type of weather conditions are prevailing at the time?
In which part of the country is your painting set?
What time of the day is it?

Each of the answers to these questions regarding conditions will have a dramatic effect on how we perceive the water. There is no one answer that could adequately cover all of the above questions. As an experienced landscape artist, I know that you will find all of the answers as you become more skilled in the art of painting in watercolour. My advice to anyone who wishes to feel more confident in painting water is: paint outdoors, directly from nature, as often as you can; sketch and make colour notes of as many different forms of water as you are able; and simplify the scene before you.

Observation is the most important skill that you can acquire. Train your eyes to see the most important details in your composition and then simplify the scene. This will make the act of painting so much easier.

What colour is water?

Whenever I ask a group the question, 'What colour is water?', the answer give is usually the same – blue. True, water sometimes looks blue but as artists, we have to search for the other colours that are there – the greens, yellows and purples, etc.

As I have already said, the act of painting water requires great observation and, of course, simplification. It is difficult to condense the skill of painting water into just a few pages, but a step-by-step demonstration should help the beginner, and perhaps the more experienced artist, to become more proficient in this skill.

Step 1. *I drew the outlines of my composition on to 200 lb Saunders Waterford NOT surface watercolour paper using a 2B pencil. After wetting the whole of the paper using clean water, I painted in the sky and applied a thin glaze of colour to the water area using mixes of Prussian blue, cobalt blue, cerulean blue and crimson. The painting was left to dry.*

Step 2. *Using a thin variegated glaze of Prussian blue, cerulean blue, crimson and orange, I quickly painted in the distant trees on the left-hand side and some reflections in the water. Next, I started to paint in the shadow sides of the rocks, using a thin glaze of Indian red and cerulean blue. The painting was left to dry.*

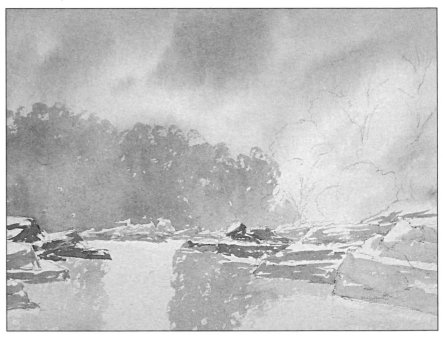

Step 3. *I mixed Indian red and ultramarine blue and strengthened the cracks and the shadows on the rocks. With a mix of cadmium yellow, Indian red, ultramarine blue and cerulean blue, I painted in some rock reflections in the water and then let the work dry.*

Step 4. *I painted in the near trees using various mixes of the same range of colours used in Step 3. For the rock reflections, it is very important in this type of misty painting to keep the greens in a grey tone. In order to give character to the rocks, I applied glazes of orange, purple and light red to these areas. The painting was allowed to dry.*

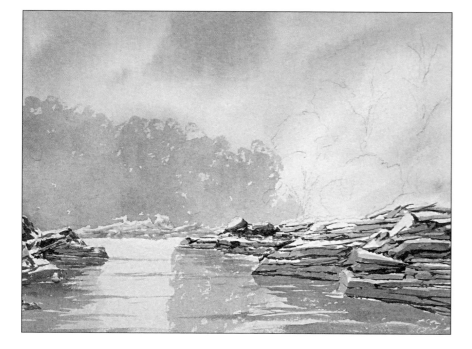

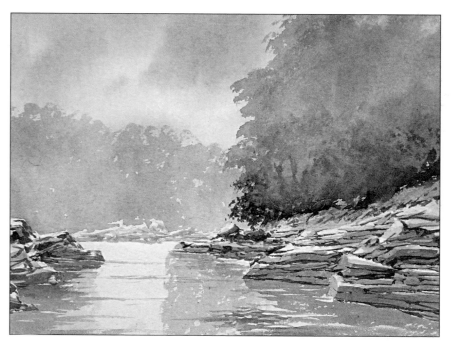

Step 5. *Using lemon yellow, yellow ochre and Prussian blue, I mixed a turquoise green colour and applied broken glazes to the water area. When this colour was almost dry, I touched in some raw umber and raw sienna. Then, using a diluted mix of raw umber, raw sienna and Prussian blue, I painted in the tree trunks of the right-hand trees. The painting was left to dry.*

Step 6. *Using a purple grey, I darkened the rocks at the water level. Then, using my dark colour, I made the cracks in the rocks darker and stronger. Using the same colour, diluted a little, I painted some dark birds in the sky, and some lighter ones using a little opaque white. The painting was then complete and allowed to dry.*

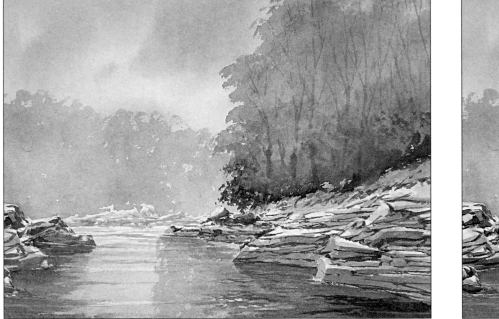

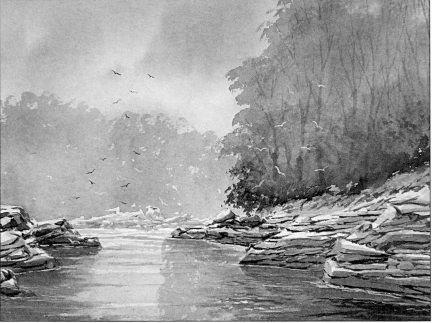

I hope that the above demonstration will help you to make a start on painting water. Why not try painting the painting below as an exercise? There are many illustrations in this book that depict water in its many guises. You just have to practise. Do not worry if you fail at first because you really can learn from your failures. After all, it is only a little paint and a piece of paper.

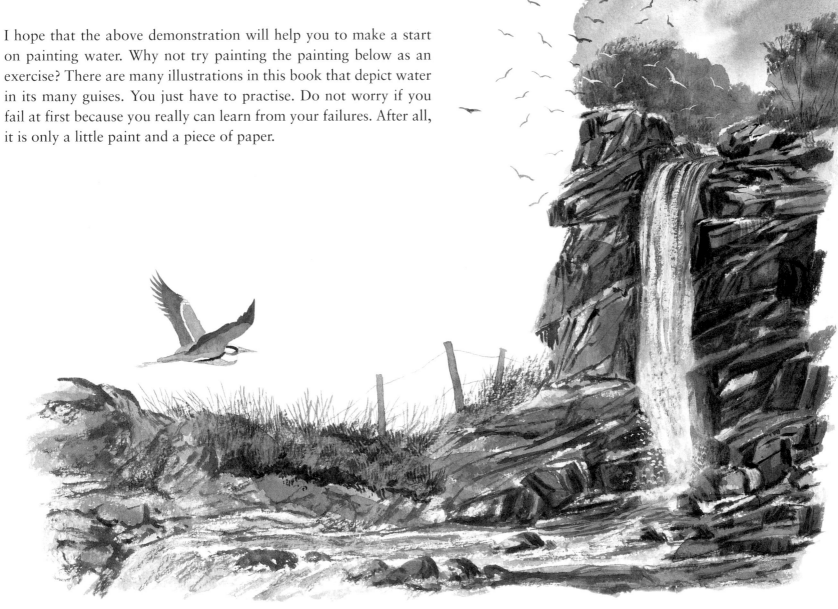

In Search of Food 28 x 38 cm (11 x 15in.)

I feel that it would be useful for me to show you a few examples of my paintings depicting water.

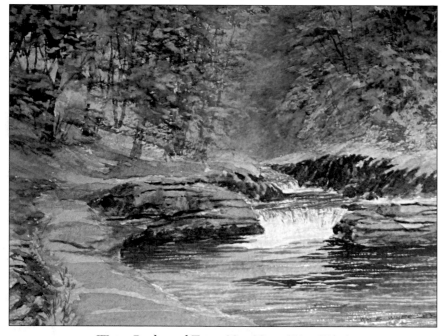

Water, Rocks and Trees. 28 x 38 cm (11 x 15 in.)
This pleasant composition will, I am sure, evoke memories for many of you.
It is the type of scene that most landscape artists enjoy painting, myself included!
I have painted this subject many times, at different times of the day and in every
season and I have never tired of doing so.

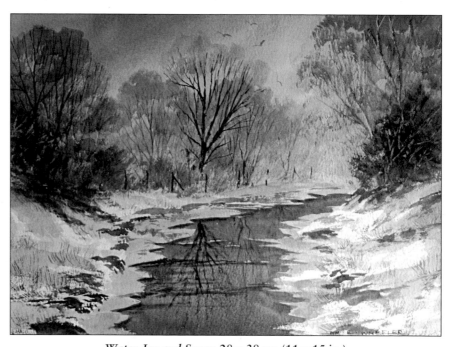

Water, Ice and Snow. 28 x 38 cm (11 x 15 in.)
I have to admit that I have a fascination with this type of scene. The ice has begun
to thaw, leaving these wonderful jagged shapes at the edge of the water, and of
course you have nature's storehouse of lovely, harmonious greyed colours.

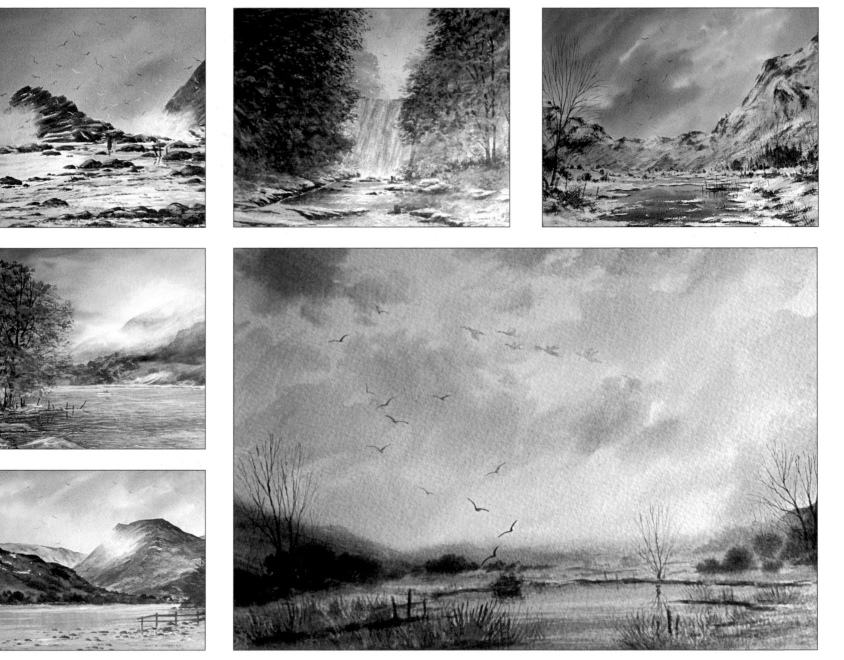

Gallery of Waterscapes

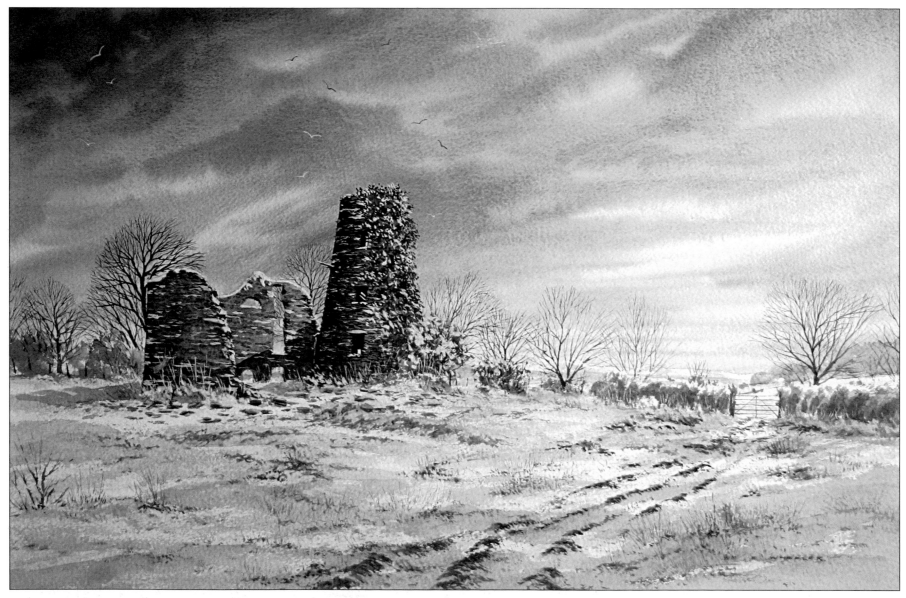

A Relic of the Past. 28 x 38 cm (11 x 15 in.)

I first came across this interesting scene a few years ago when out on a sketching trip. I love walking down country lanes, especially ones that are new to me, in the hope of finding that special painting subject. Well, I did – the remains of this lovely old windmill, sitting on a hill above the Vale of Glamorgan! I have painted it many times and at different times of the year but I just could not resist painting it in the snow.

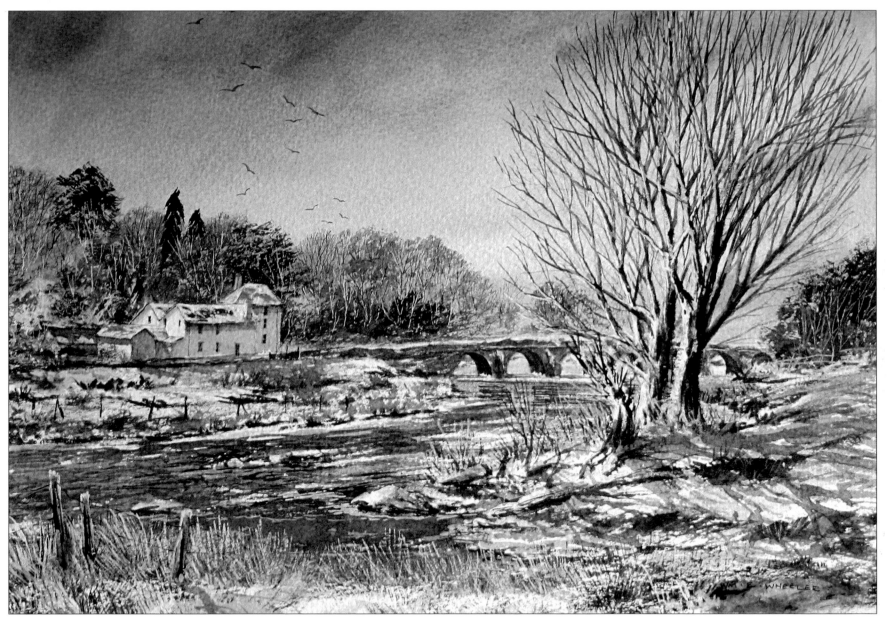

The Bridge at Abergavenny, South Wales. 28 x 38 cm (11 x 15 in.)

This ancient and beautiful monument can be found on the outskirts of Abergavenny. Approached from the marshy grasslands, it presents the artist with a subject not to be missed.

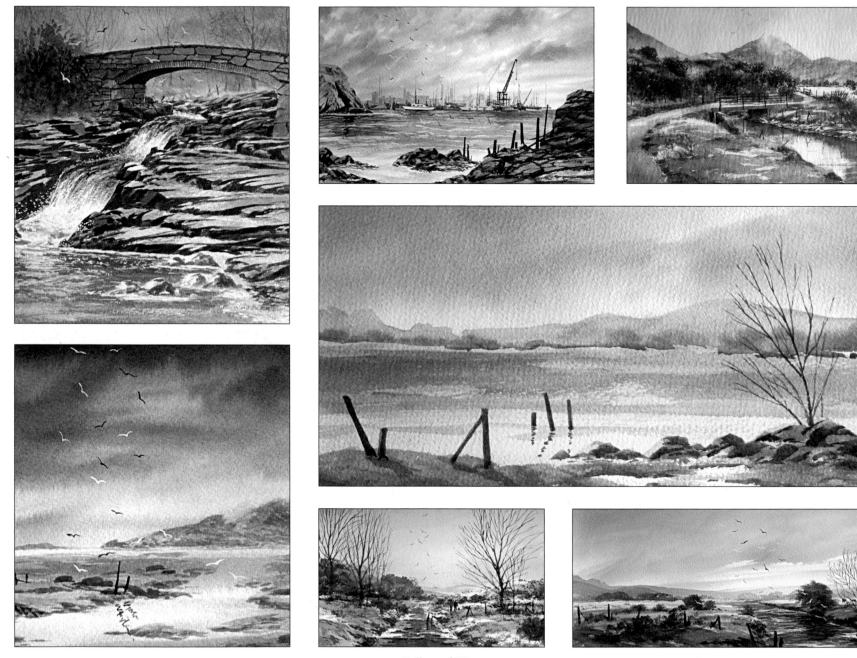

Gallery of Waterscapes

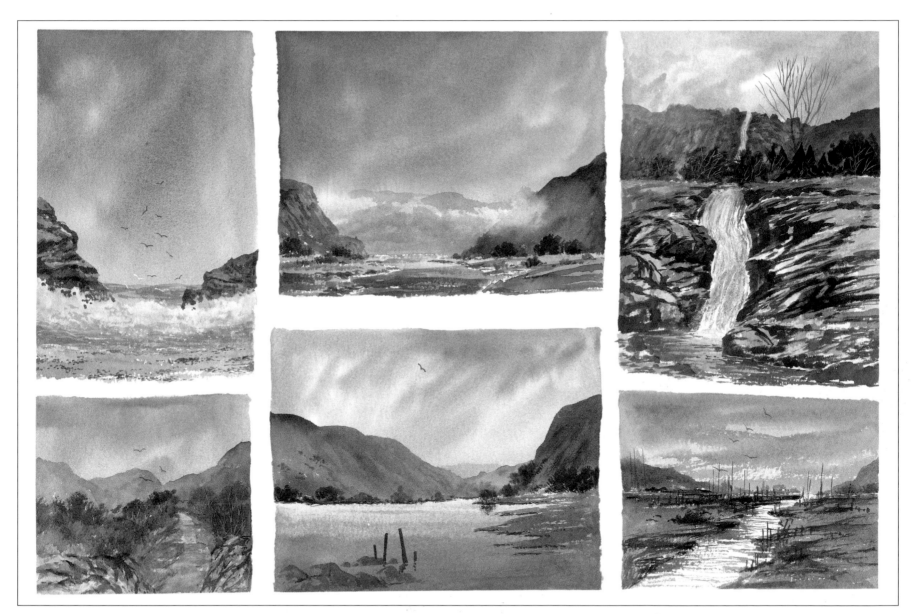

Here is a selection of my cameo paintings to further illustrate my technique for painting water.

Painting buildings and bridges

I believe that in many books on painting, information on the important subjects of composition and perspective are placed out of context, making it more difficult for the reader to learn and use the basic principles with ease. For this reason, I have presented the rules of composition at the start of the chapter on techniques, just before the section on painting skies. Now I am starting this section with the rules of understanding and using perspective, because the use of perspective is so important for painting buildings and bridges. I am very aware of the trepidation that students experience when the word perspective is even mentioned, so I hope that you will find the following approach an easy and enjoyable one for mastering this skill.

My method for introducing this subject will be based on just one type of perspective, together with the use of ascending and descending vanishing points. Do not worry about these at this stage! They really are not as difficult as they sound. Also, I will be approaching the subject as a practising landscape artist working outdoors, which is an important factor.

Let's start by talking about perspective. What is it? I usually explain it as being a constructive drawing technique which will give the illusion of a one-dimensional object becoming three-dimensional. I believe that it is essential for artists to have a working knowledge of this skill. Remember that perspective is only an aid. It must not be used as a crutch to attempt to cover up bad drawing techniques.

There are many differing types of perspective, but there is one line that is constant to them all. This is called the Eye Level Line, which we will refer to as our E.L.L. from this point on. We are able to find our E.L.L. wherever we are by holding a pencil level in front of our eyes and at arm's length: the point where our eyes meet a distant surface or object along the line of the pencil is our E.L.L.

> **Remember that the E.L.L. is the one constant line. You can only have one E.L.L. in each perspective.**

The E.L.L. is the main line in your perspective. On this line, you will have your Vanishing Points, which we will refer to as V.P.s from now on. A V.P. is the place where some of our perspective lines will seem to converge. The sketch below of a straight road running into the distance will explain this quite well.

As we look at the road, it gives the impression of becoming narrower as it goes further away from the viewer. We know of course that this cannot happen but we have this illusion. This is the basis of perspective.

> **You can have any number of V.P.s on your E.L.L. in the drawing of your perspective. Lines which go into your drawing towards your E.L.L. should go to a V.P. All other lines should run parallel with the E.L.L.**

Let's construct a simple box shape, using the rules given above.

Step 1. *Draw in your E.L.L. and mark it as such.*

Step 2. *Place a V.P. on the E.L.L. in any position other than the centre.*

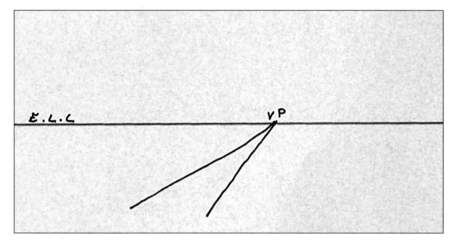

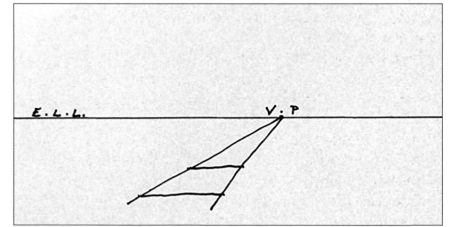

Step 3. *Draw two lines at any angle from the V.P.*

Step 4. *Draw two parallel lines joining up the lines from the V.P.*

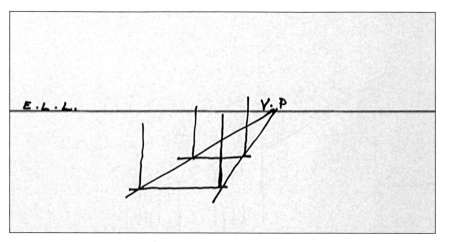

Step 5. *Place upright lines in each corner.*

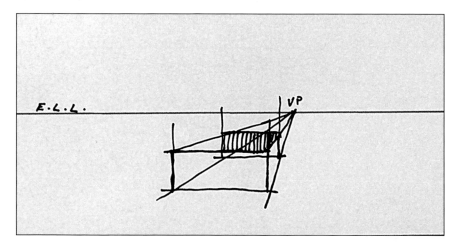

Step 6. *Mark a height point on the nearest corner upright, and a rule line to the V.P. Remember that lines which do not go towards your V.P. run parallel with your E.L.L. We have now completed the box shape.*

If you can draw a box shape, then you are able to draw a house. A house is only a box with a roof on it. The rules and sequence of steps are just the same. From this point on, we will begin to use this information to draw scenes as we would when working outdoors.

We will be introducing two additional items, ascending and descending V.P.s, which we will use with the above guidelines. They will make the act of using perspetive very much easier. Before we move on, I think it is a good idea for me to explain just exactly what these V.P.s are and what they do in a perspective. They are simply an extension of some of the V.P.s you have on your E.L.L. and they can be drawn either up or down. You can have as many ascending or descending V.P.s as you require and place them wherever you need them. To draw an ascending or descending V.P., first make sure you have marked all your V.P.s on the E.L.L. Then, to turn a V.P into an ascending or a descending V.P., simply draw a line either up or down from the V.P. on the E.L.L. I know from personal experience that there are many distortions that can take place in the setup of a perspective. One of the main causes of this is that the size of the paper is too small or the drawing is too large, putting the V.P. too close to the object being drawn.

I do not wish to delve any deeper into the subject at this time, for I believe that to do so would only create confusion in the minds of most readers. Instead, I have included a number of perspective sketches showing simple perspective with one or two V.P.s and some showing the use of ascending and descending V.P.s. All of the sketches are used to construct compositions which the landscape artist will be faced with and will hopefully enjoy drawing. As I stated earlier, there is no point in just producing simple box shapes – let's use perspective as artists.

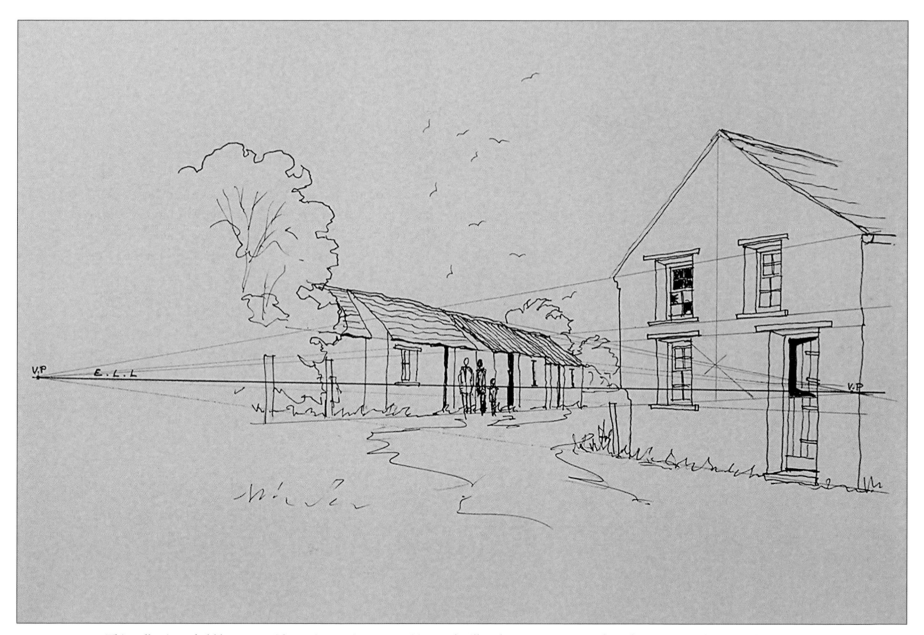

This collection of old barns provides an interesting composition and will make a nice painting. If you have studied the rules of perspective and practised the techniques, then this exercise should present you with no problems. Try it until you get it right, then attempt to paint it.

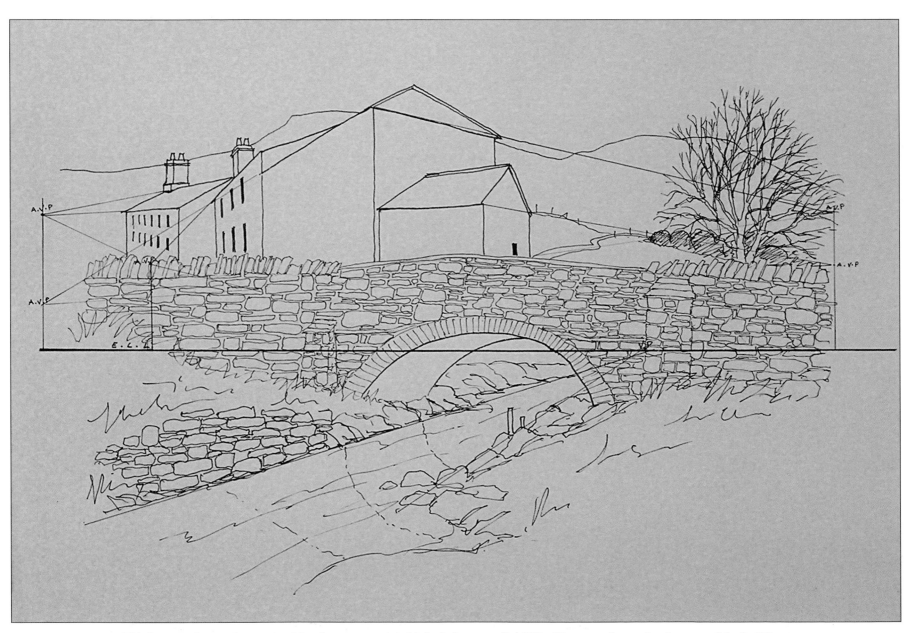

This is a very interesting composition for you to try and it includes ascending V.P.s. You may also notice that one of the buildings does not look quite right. This was deliberate on my part, just to make you aware that when you sit outdoors working, perhaps on very old buildings, they could be all shapes and sizes. Remember to draw them as they are, for these are the things which help to provide atmosphere and character – something which all artists should be searching for.

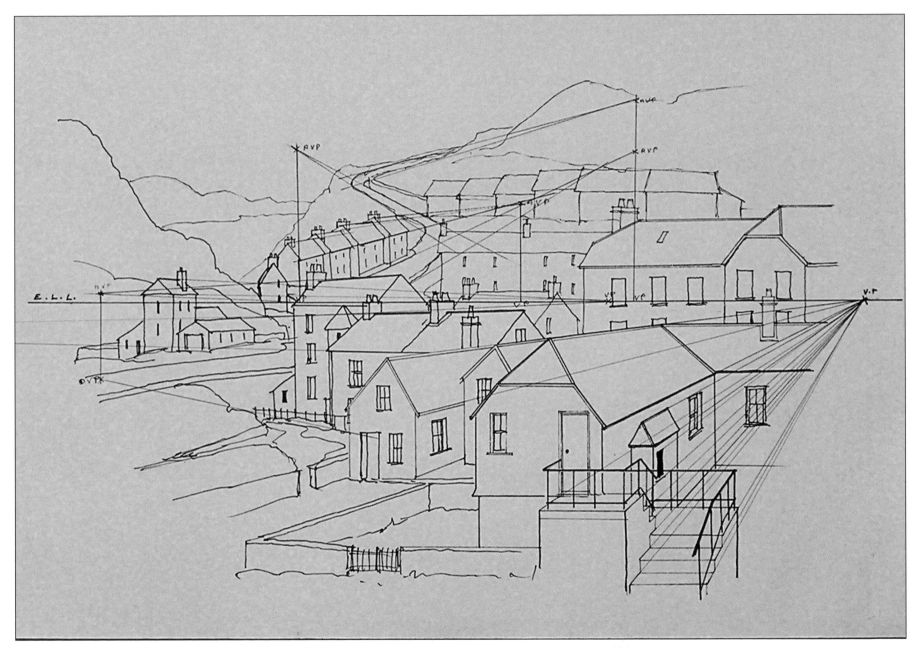

This is a more difficult composition but one that shows how ascending and descending V.P.s will help you to create the impression of going up or down hills. Study it carefully and try to draw it yourself.

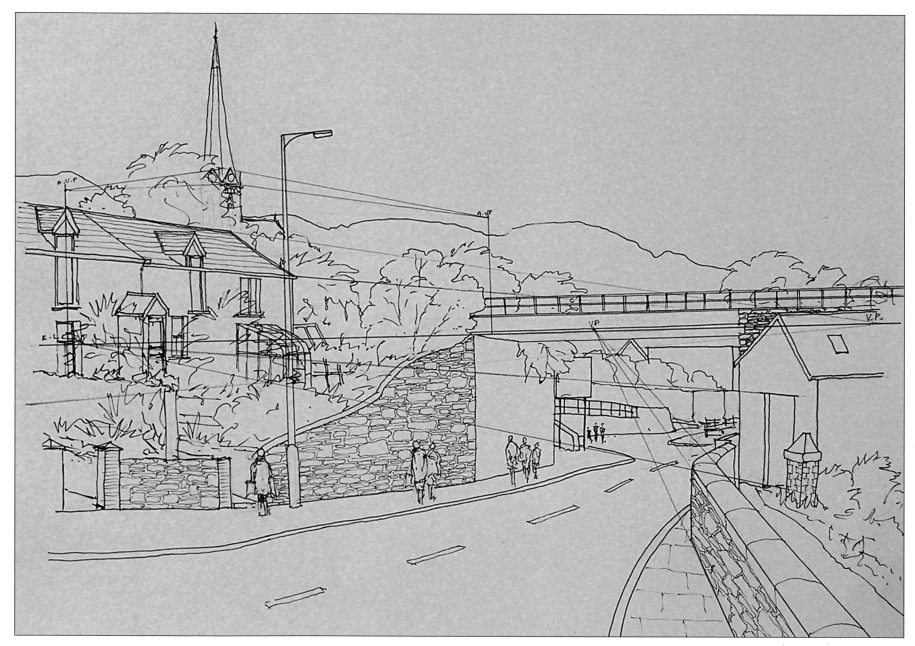

This is another interesting perspective drawing and one that I am sure will provide you with plenty of problems. I am certain that if you have studied and practised drawing all of the compositions I have given you, you will be well on your way to being able to understand and use perspective.

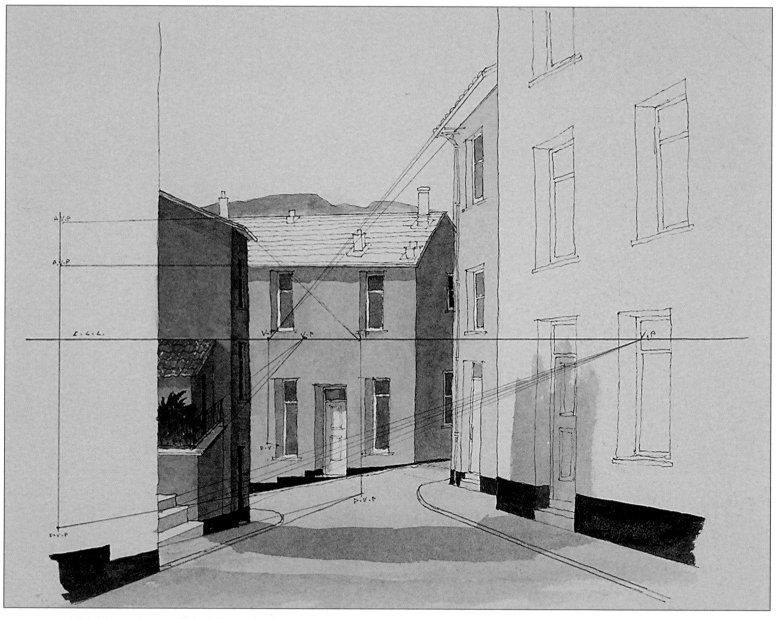

This illustration is a little different from the others. I felt that it was important for you to see all of the construction lines as
I started to paint the scene. I used a fine waterproof pen to outline the drawing and then started to apply some glazes of colour. You would
of course normally remove all of the construction lines before painting the scene.

I hope that you have enjoyed this short, but hopefully instructive, introduction to the technique of drawing in perspective. I feel that the next logical step would be for you to see a step-by-step demonstration, showing you how I set about painting a street scene. I have chosen to paint this scene in the village of Corchiano in Italy.

Step 1. *Using a 2B pencil, I lightly drew out my composition on to 140 lb Bockingford NOT surface watercolour paper.*

Step 2. *Using a glaze of cobalt blue and cadmium orange on a dry surface, I covered most of the paper, taking great care to leave the figures, the tops of the doorsteps and the left-hand foreground building as white paper. The painting was left to dry.*

Step 3. *Using glazes mixed from raw sienna, burnt sienna, crimson, ultramarine blue, cadmium yellow and neutral tint, I painted in all of the buildings with the exception of the one on the left in the foreground. Once again, I made sure to paint around the figures. I then let the painting dry.*

Step 4. *Using a mix of ultramarine blue and burnt sienna as my dark colour, I started to paint more detail into my composition. Cast shadows were made from a mix of ultramarine blue and crimson and applied thinly with a large brush. I began to paint in the figures using a variety of colours. When these were finished, I started to paint the foreground building using glazes mixed from burnt sienna, yellow ochre, crimson, ultramarine blue and neutral tint. The painting was then left to dry.*

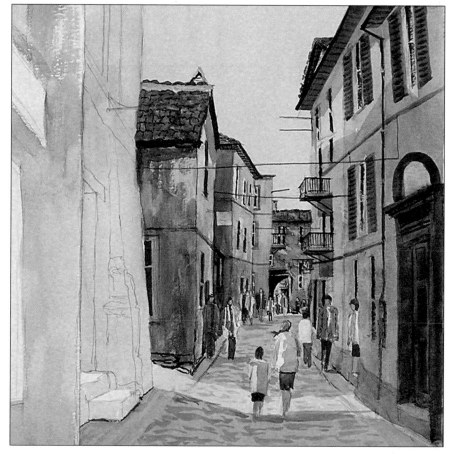

Step 5. *I completed the foreground building, then painted a few birds into the sky using my dark colour. I decided that the composition needed two figures in the foreground, and I painted these in using watercolour and a little body colour. Upon reflection, I feel that my instincts were justified. The painting was left to dry.*

Step 6. *My final touch was to paint in details on the stone and brickwork on the foreground building. The painting was left to dry.*

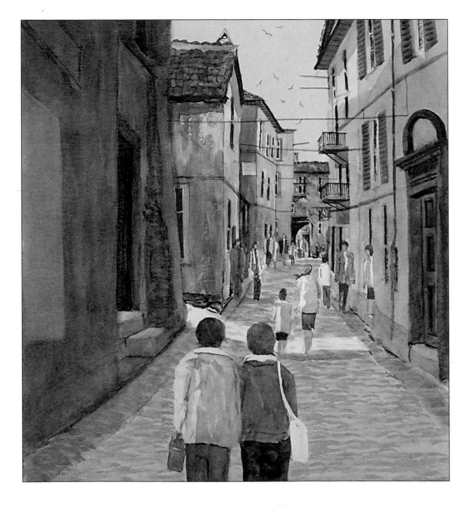

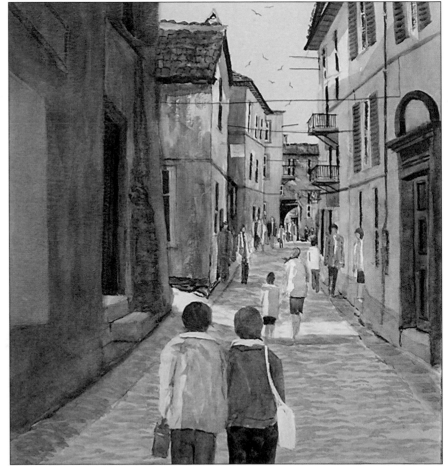

Before we reach the end of this section of the book, we really must look at some of the most overlooked and neglected parts of our everyday landscape. These are overlooked by many, I hasten to add! They are our bridges, and very interesting and varied structures they are. Unfortunately, most of us walk, drive or ride across them each day of our lives without really seeing them. What a waste, because they very often played a big part in our history. Anyway, I like them because they are one of the many artistic props that the landscape artist can use to produce a painting. I thought long and hard about the best way to introduce bridges into this section on buildings, as they are, after all, structures built by people. I decided to select a few of my favourites and to show them as small cameo paintings. I hope that they will strike a chord with those of you who, to date, have never really looked at them – hopefully, these images will make you want to.

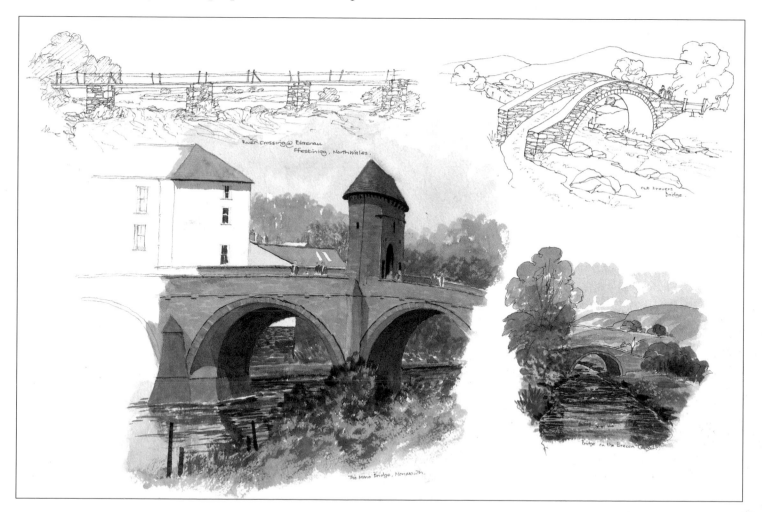

River Crossing @ Blaenau Ffestiniog, North Wales.

Old Drovers Bridge.

The Mono Bridge, Monmouth.

Bridge in the Brecon

Painting people and animals

Does the inclusion of people and animals enhance your paintings? The answer to this question cannot be a simple yes or no. The dictionary definition of the word 'enhance' is 'to increase in quality, value and attractiveness'.

Would the inclusion of people or animals into your composition increase the quality of the work? Other than in the broadest sense, I would say no. Quality in a painting comes in the main from constant practice and improving your mastery of the skills.

Would including them increase your composition's value? Once again, only in the broadest sense. They might increase the practical value, or financial value, of your work, but your time would be better spent improving your technique and the standard of your work.

Would their inclusion increase your painting's attractiveness? This could be the one word in the definition that I would accept as true. Many viewers and buyers of artwork enjoy, and sometimes insist on, paintings having people and animals in the composition.

I would like to suggest another word, however, and that is 'necessity'. Are the inclusion of people or animals necessary in a painting? My answer would be: sometimes. Let me give a few examples. If you are painting a city or a town, you really would have to include a lot of people and cars, etc. If, however, you are painting a rural or pastoral scene there may be fewer, or perhaps no, people, but there could be a variety of animals.

In this section I am going to try to show you how a composition can actually be improved by including a number of carefully chosen and selectively placed people and animals. I do not intend to spend too much time going into the technical side of how to draw people or a particular type of animal. I would prefer to emphasise the importance of selecting and positioning them correctly. We will do this using a few small step-by-step demonstrations, using both a rural landscape and street scenes as examples.

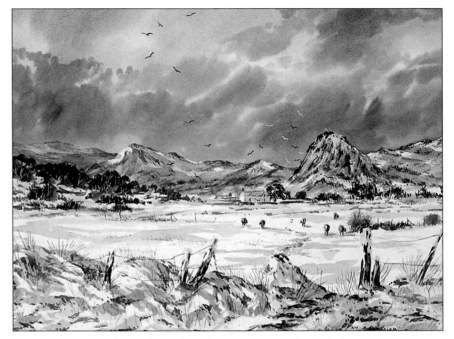

Snow on Bird Rock 28 x 38 cm (11 x15 in.)

Bird Rock is a very prominent landmark in mid-Wales. It is inland but known to be a popular nesting place for cormorants and a favourite location for many artists and photographers.

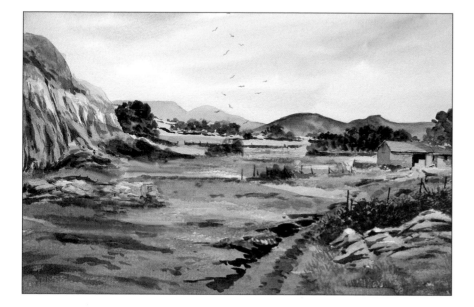

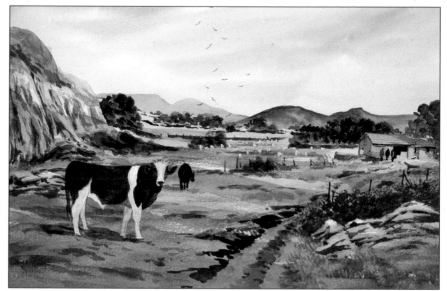

This painting shows the scene without any signs of life, with the exception of a few birds in the sky. The composition is not too bad but I feel that the addition of a few animals and some distant figures will bring a little life to the composition and make a great difference to the scene. Rather than paint two very similar paintings, I painted this landscape first and photographed it. Then, when the work had dried, I drew in the animals and figures over the watercolour using a graphite pencil and painted them in using a combination of watercolour, gouache and pastel.

I think that you will agree that these few additions have altered the whole scene completely and, in my mind, for the better. Compare this painting to the previous one to see how much of an enhancement the additions have made. I am not saying that you should include animals in every rural landscape that you paint. To do this would be nonsense. The fact is that most of these types of composition work quite well without the addition of any form of life. Keep an open mind, however, and if you think that a particular scene would benefit from the inclusion of animals or figures, then use them.

Next, we will look at the use of figures in a different type of composition. In the first painting, I have drawn out a simple street scene without any people in it.

These sketches are meant only as an aid to show the importance of using people in street scenes, etc. As I stated earlier, I used watercolour and pastel pencils to carry out these exercises because they were unplanned, and I wanted to provide you with a comparison between each step. Obviously, when I am drawing a scene prior to painting it, I will draw in any people or animals to be included before the painting starts.

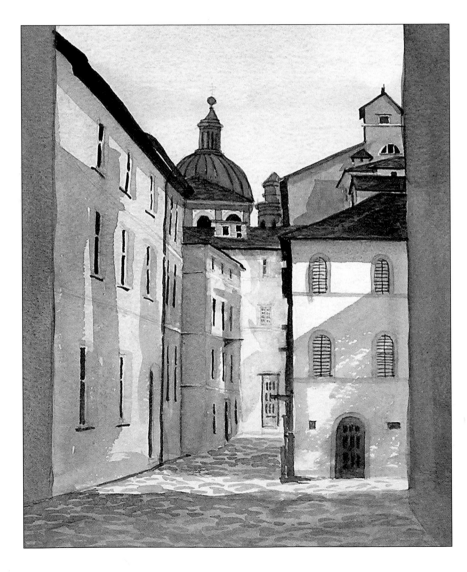
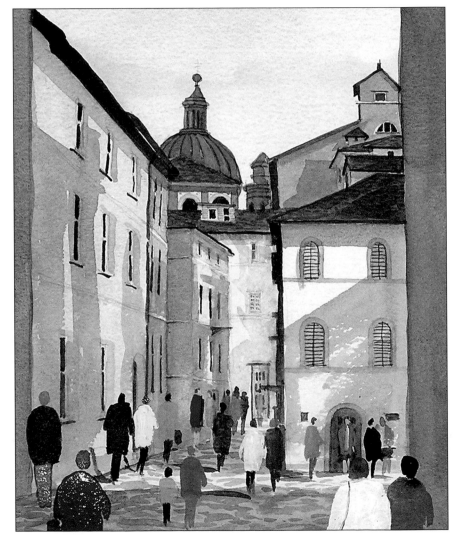

The sketch shown below depicts a crowded street scene. It is not meant to be a completed painting. It is just a quick drawing in pencil to indicate the basic shapes of the people and a little of the architecture. I applied quick basic washes, using a variety of colours to enhance the figures. As you can see here, I sometimes like to draw out my composition and paint in the figures and lower architectural details first and then paint in the rest of the scene afterwards. On certain compositions, it can work quite successfully. In the street scenes below, I must apologise if some of my colours seem a little bright. I felt that in these examples I needed to emphasise some of the near figures.

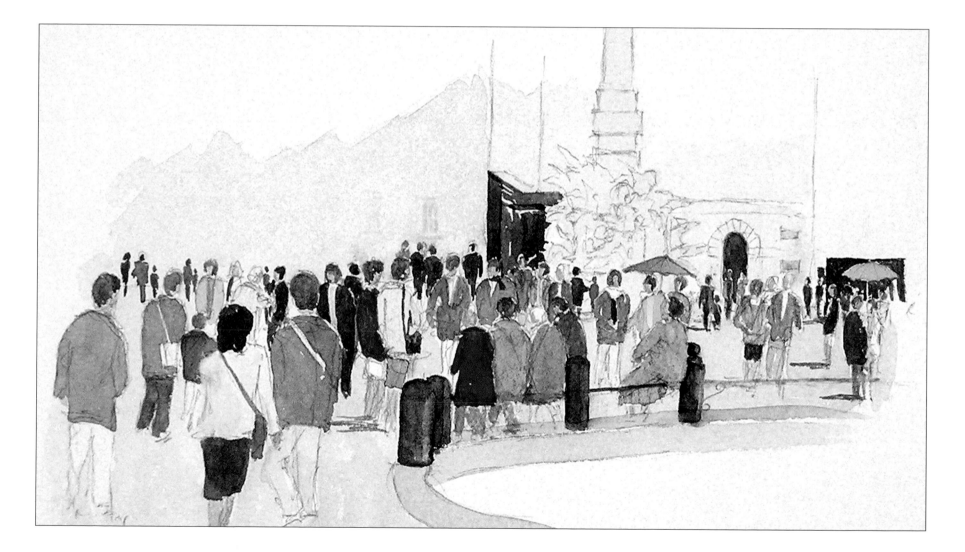

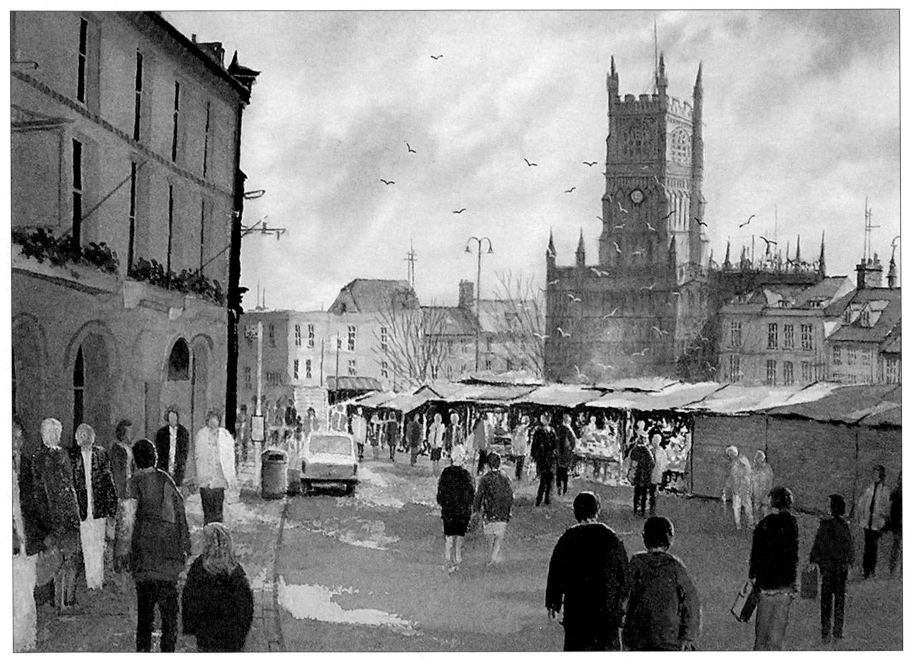

Market Day at Cirencester. 28 x 38 cm (11 x 15 in.)

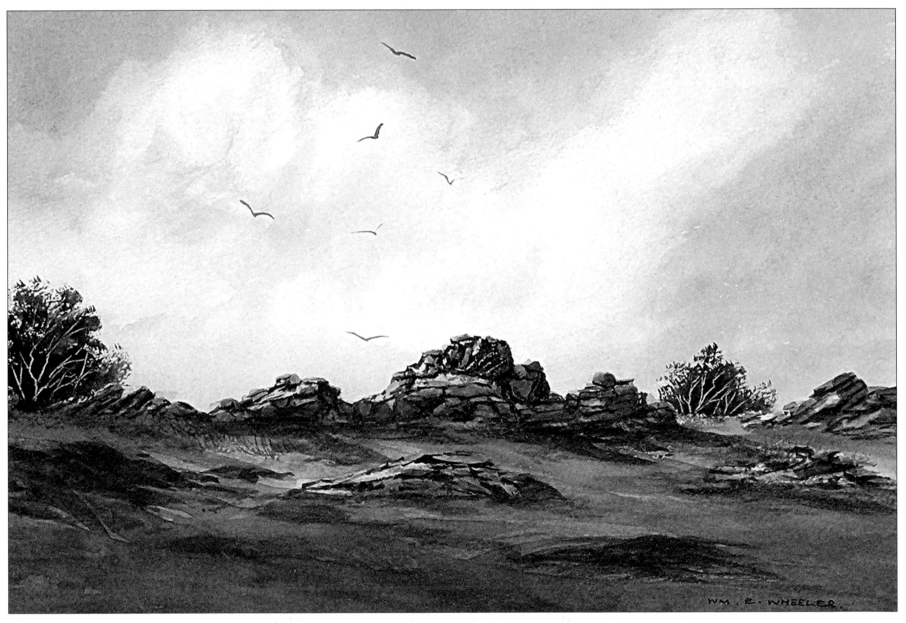

Tresco Landscape, Isles of Scilly. 28 x 38 cm (11 x 15 in.)
All over the island you will see huge piles of rocks forming natural sculptures – this painting depicts one such structure.
I feel that it is very interesting and makes a good composition.

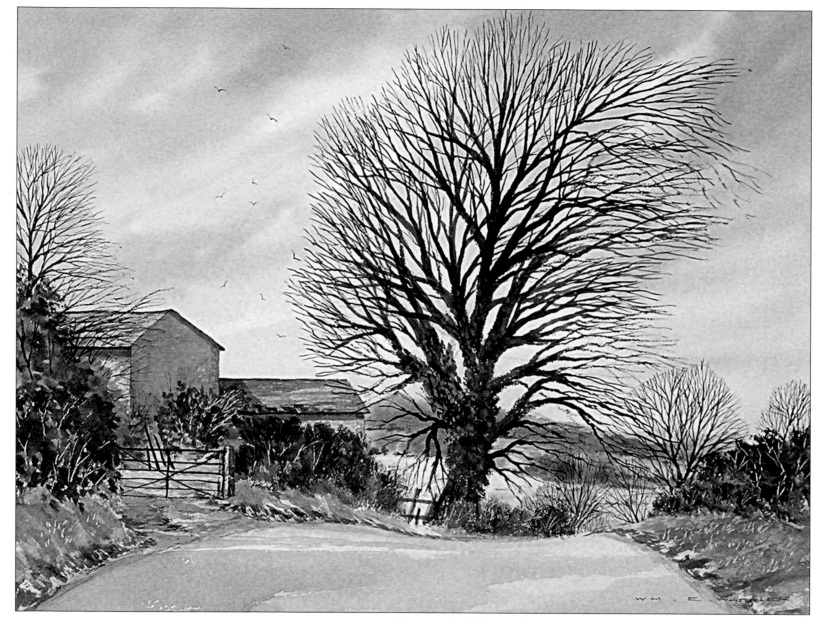

Old Farm, Nr Cardiff. 28 x 38 cm (11 x 15 in.)

I came across this delightful little composition while out on a local sketching excursion. I had decided to spend the morning doing some drawing, in search of a new subject matter. This scene attracted my attention and as it was a fairly quiet lane, I decided to paint it on the spot – I had an enjoyable few hours.

Trafalgar Square, London. 28 x 38 cm (11 x 15 in.)

I saw this view of Trafalgar Square from the steps of the National Gallery and knew I wanted to paint it. I took a number of
photographs and painted the scene back in my studio – I really enjoyed the challenge.

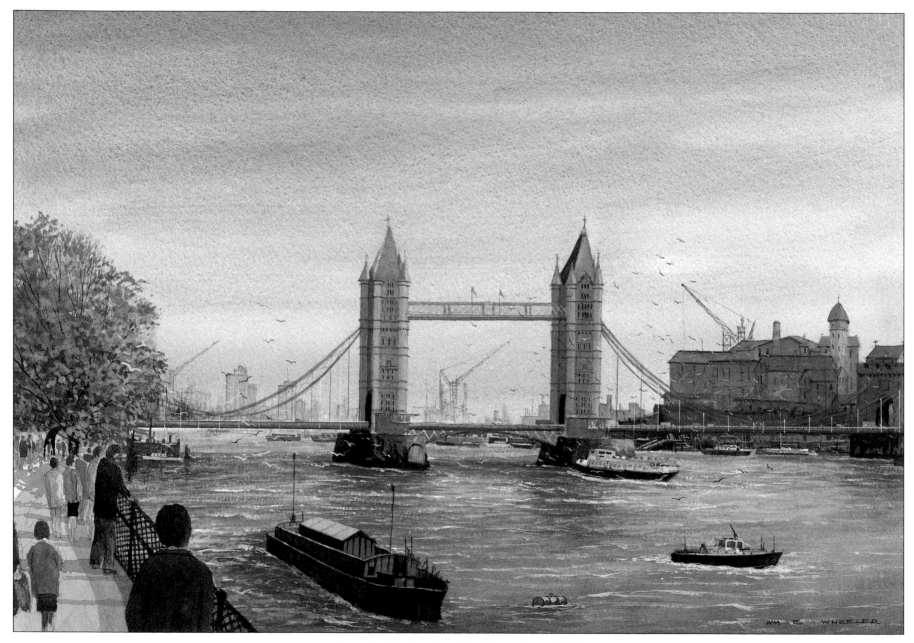

Tower Bridge, London. 28 x 38 cm (11 x 15 in.)

I saw this view of the bridge from the walkway by the Tower of London and felt that I would like to paint it – it was quite a challenge.

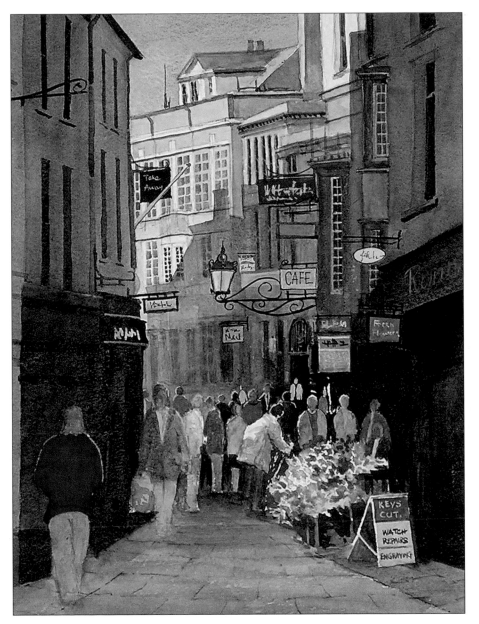

A Splash of Colour. 28 x 38 cm (11 x 15 in.)

I was in the town of Devizes in Wiltshire to do a demonstration for a local society. As I was walking around, getting to know the town, I came across this scene, which I thought would make a good composition on which to build a painting. Due to lack of time, I took a few photographs and produced this painting back in the studio.

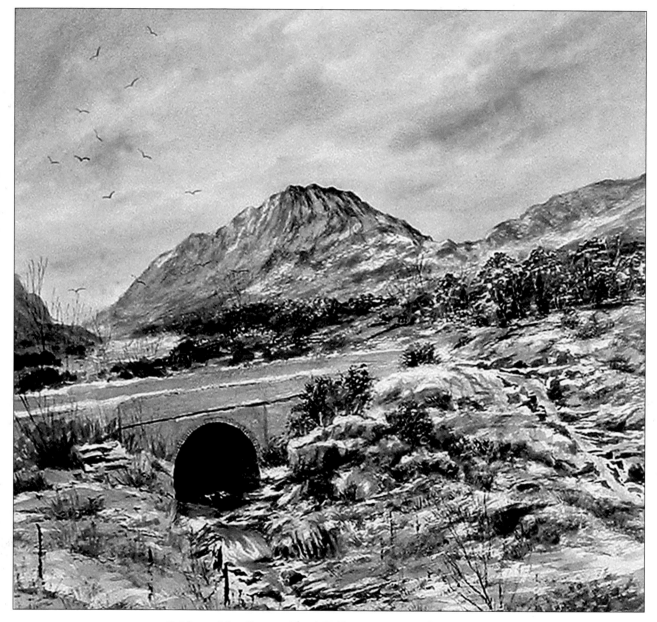

Bridge at Llyn Ogwen, North Wales. 28 x 38 cm (11 x 15 in.)

This area in winter is quite spectacular; there really are so many subjects, just waiting to be painted. Why not attempt this one as an exercise?

Try and work out the range of colours I used.

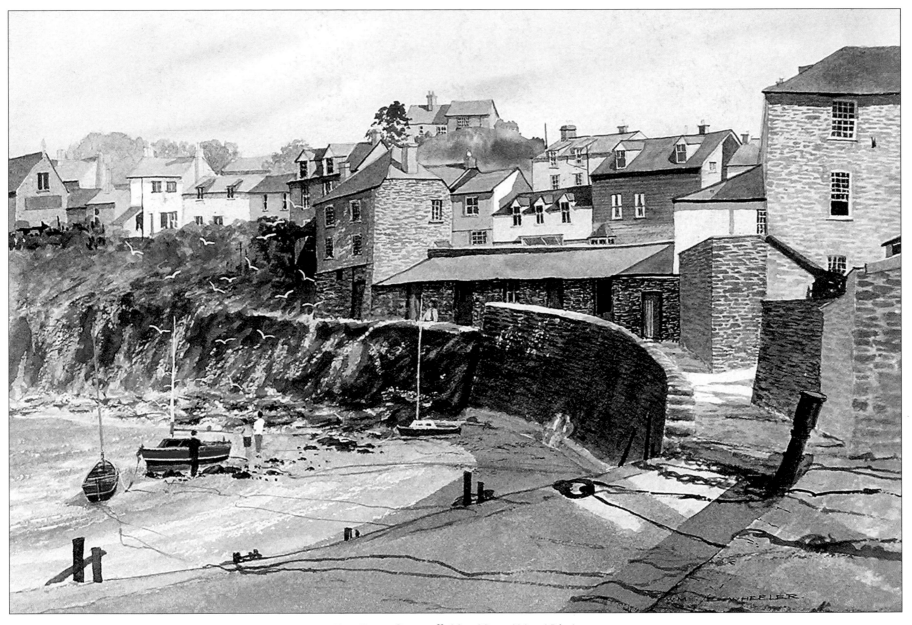

Port Isaac, Cornwall. 28 x 38 cm (11 x 15 in.)

Whenever I run a watercolour course in Cornwall, I always pay a visit to this historic little fishing village.

It is full of interesting painting subjects – each time I go there I see something new to paint.

CONCLUSION

Now we have reached the end. For me, this is the end of the most rewarding and demanding task that I have ever undertaken, and one that has at times pushed me to my limits. I have to say, however, that I have enjoyed every moment of the experience. Hopefully, for many of you reading this book who have the burning desire to master this most elusive skill, this is just the beginning! To you all I would simply say, think about joining an art society, group or class where you will be amongst people with the same interest. This will help you to keep your mind focused on the task ahead.

After you have read this book, and perhaps even practised painting some of the examples, if you feel that watercolour is the medium for you, then I would say that this book has been successful.

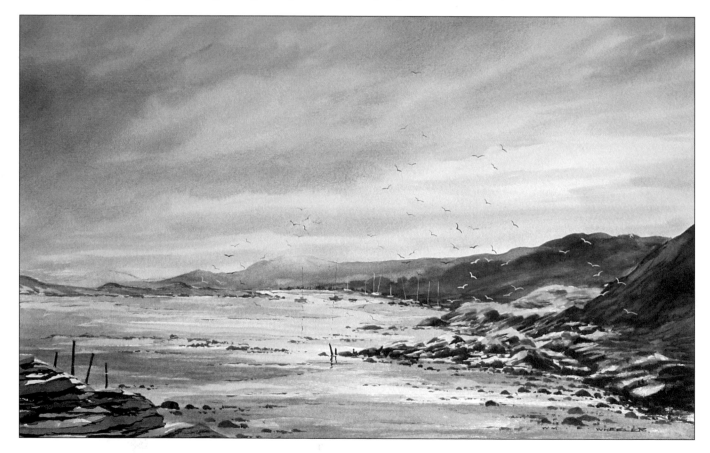